D1252116

An Introduction
to Visual Theory
and Practice
in the Digital Age

This book is part of the Peter Lang Media and Communication list.
Every volume is peer reviewed and meets
the highest quality standards for content and production.

PETER LANG
New York • Washington, D.C./Baltimore • Bern
Frankfurt • Berlin • Brussels • Vienna • Oxford

Brooke Barnett, David Copeland,
Harlen Makemson, Phillip Motley

An Introduction
to Visual Theory
and Practice
in the Digital Age

PETER LANG
New York • Washington, D.C./Baltimore • Bern
Frankfurt • Berlin • Brussels • Vienna • Oxford

Library of Congress Cataloging-in-Publication Data

An introduction to visual theory and practice in the digital age /
Brooke Barnett... [et al.].
p. cm.
Includes bibliographical references and index.
1. Digital video. 2. Multimedia systems. 3. Visual perception.
4. Mass media. 5. World Wide Web. I. Barnett, Brooke.
TK6680.5.I589 006.6'96—dc22 2011000028
ISBN 978-1-4331-0904-1 (hardcover)
ISBN 978-1-4331-0903-4 (paperback)

Bibliographic information published by **Die Deutsche Nationalbibliothek.**
Die Deutsche Nationalbibliothek lists this publication in the "Deutsche
Nationalbibliografie"; detailed bibliographic data is available
on the Internet at http://dnb.d-nb.de/.

FSC
Mixed Sources
Product group from well-managed
forests, controlled sources and
recycled wood or fiber
Cert no. SCS-COC-002464
www.fsc.org
©1996 Forest Stewardship Council

The paper in this book meets the guidelines for permanence and durability
of the Committee on Production Guidelines for Book Longevity
of the Council of Library Resources.

© 2011 Peter Lang Publishing, Inc., New York
29 Broadway, 18th floor, New York, NY 10006
www.peterlang.com

All rights reserved.
Reprint or reproduction, even partially, in all forms such as microfilm,
xerography, microfiche, microcard, and offset strictly prohibited.

Printed in the United States of America

Brooke Barnett
For Tom, Lily and Jack

David Copeland
For Robin

Harlen Makemson
For Deb and Dan

Phillip Motley
For Robin, Griffin and Maxine

Contents

Acknowledgments

Elon alumni Miriam Williamson created the design for the book and Hunter Copeland took the cover photograph. Phillip Motley created the cover concept. Many people contributed time for interviews, wrote side bars, and donated photos for use in this book. Thank you to Kelly Carlton, Monty Davis, Bob Driehaus, Ellen Hartman, Andrea Hsu, Jim Kelly, Yung Soo Kim. Layla Masri, J. McMerty, Tom Mould, George Padgett, Liz Palmer, Martin Patience, Steve Raymer, Frank Stascio, David Stephenson, Margot Stephenson, Marcelle Turner, and Anthony Weston. We are blessed with wonderful colleagues at Elon University. Specifically, Connie Book, Vic Costello, Don Grady, Gerald Gibson, Ray Johnson, Nicole Triche, and Staci Saltz looked at versions of the manuscript or gave us ideas for things to include. Coming to work at Elon is a pleasure. But even better is to come home to our amazing and supportive families.

1 The Changing Media Landscape

For better or worse, the media landscape isn't what it used to be. Yes indeed, times they are a changin'! Over the last fifteen or so years huge advances in the nature of digital technology have spawned a wide array of new media platforms, channels and delivery mechanisms through which you receive (and sometimes deliver) a staggering amount of content. This changing landscape provides you, both as a consumer and producer of media, with many exciting new options to consider when choosing how and from where you get your information. This new-found richness of options comes at a price, though. Exercising the many options you are now confronted with can sometimes be a bit more complicated than operating your television's remote control unit. This is true when you are acting solely as a media consumer but is of equal, if not greater, concern when you find yourself at the other end of the consumption spectrum, as a producer. Since the purpose of this book is ultimately to help future media professionals—like yourself—find their way through this potential morass, we'll focus most of our energy on your role as a producer.

If you're even somewhat up to speed with what today's media landscape looks like, you know that getting your daily measure of media, regardless of type or how it's delivered or even how it's produced, isn't as simple as it used to be. Sure, you can still turn on the tube, change a channel or two, and, just like you used to do, slip into autopilot mode while watching the evening newscast. However, if you want to engage with content of the new media type, then you've got to be willing to become more actively involved. This willingness on your part will reap you two great rewards: "more" and "now."

You arrive at the "more" through the simple fact that new media are ubiquitous. Content is everywhere and is provided to you through

myriad distribution channels. You have at your disposal a wide selection of media content. The World Wide Web alone presents you with a breadth of information that is far greater than even the most robust cable television services can provide. Your willingness to engage with new media as a means of obtaining information undoubtedly exposes you to a wider swath of more and better content.

To get to the "now," you need only consider another simple truism of virtually all new media: It's always available. The delivery of new media content isn't relegated to a specific time of day or day of the week, as is the case with most traditional broadcast media such as television or radio programming. New media aren't delivered to your home or office each day at a certain time—think newspapers—or each week or month—think magazines. New media are instead instantly available to you at all times of the day or night and they're constantly updated. When a news story breaks, articles shows up on numerous Web sites only minutes after they've been written. As new developments to the story arise, the available content is updated on the fly. The same phenomenon definitely doesn't happen with traditional print media and rarely does with broadcast media unless, of course, the particular news event is of such stupendous concern that there's a need—and willingness—to break into regular programming.

Normally, with older forms of media, you're forced to wait for the next day's newspaper delivery or the evening news broadcast or your favorite radio show to access the same information that you can get twenty-four hours a day by visiting one of many new media resources.

Yes, media content—and the ways in which you use it and create it—is definitely changing. A large percentage of the content we consume has actually already changed quite a bit; the rate of that change is accelerating faster and faster. Technological innovations keep the new media landscape continually in flux. It really doesn't take all that long for nascent technologies to lose the sheen of their newness. Fresh platforms, software tools, and hardware devices arrive on the scene with alarming frequency making the job of defining exactly what the media landscape looks like today a difficult task, a moving target at best. Before attempting to do so, it's important that you first take a closer look at what types of media currently

> Fresh platforms, software tools, and hardware devices arrive with alarming frequency making the job of defining exactly what the media landscape looks like today a difficult task, a moving target at best.

at your disposal are more or less the same as they've been historical-ly, what's already changed, and what new forms will likely be available in the very near future.

Defining Old Media and New Media

We've reached a point in the developmental trajectory of the media industry that we can refer to media as being either "new media" or "old media" without getting into too much trouble. Old media are what you're accustomed to: television, radio, newspapers, magazines, etc. New media are most often associated with content that's accessible "online," which simply means that the information is available via a virtual network, the Internet being the most obvious. New media also represent a shift in the manner in which you go about digesting your daily allotment of media, and they define new roles that you play as a consumer and as a producer. (Before we delve any deeper, it's important to point out that even though technological advances

> New media also represent a shift in the manner in which you go about digesting your daily allotment of media, and they define new roles that you play as a consumer and as a producer.

have provided many new options, old media are still around and are still of vital importance. They haven't disappeared and likely will not for decades, perhaps not ever.)

In the not too distant past, most media—both print and electronic forms—were delivered to you primarily in a definitively chronological format. You read newspapers, magazines, and books. You watched television, listened to the radio, and went to the movies. Most media of this type were designed—and often still are—to be consumed in a linear fashion, from beginning to end. Though it's not that hard to break the inherent structure of most linear media by simple actions such as flipping through a magazine from back to front or starting a DVD up in the middle of the film, the obvious fact is that the creators of this type of content intend to present information within a logical chronological structure. Yes, you clearly have the ability to break the chronological order of most old media content, but that's not what producers intend for you to do.

Today, though you still receive a significant portion of information from old media channels, it's also possible to keep up with the news, view educational programs, watch sit-coms, and listen to music by tapping into new platforms and delivery mechanisms that, in

addition to providing a wide array of raw information, provide you with opportunities to interact directly with provided content. New media afford you the opportunity to engage with content in novel ways, ones you simply didn't have access to in the past. You can read a blog and leave comments in response to the writing, comments that are instantly accessible to all readers; you can play video games, either against another individual or against the computer itself; you can research virtually any topic using a Wiki and can contribute information to this type of Web-based resource about subjects in which you are knowledgeable; you can download podcasts to mobile devices and listen to them wherever and whenever you choose.

Given these examples and many others like them, it's not hard to see that recent technological advancements have changed the media world. These changes give you—consumer, user, or producer—many new possibilities to explore. The fact of the matter is that you now live in a world where direct interaction with the media that you encounter is not only possible but is increasingly the norm. Intelligent, sophisticated and—perhaps surprisingly—often easy-to-use technology is part of your daily life. No matter where people are or what they are doing, the vast majority carry devices that are continuously connected. Take for example the simple cell phone. These mobile devices have evolved from existing simply as phones into miniature, portable computers (think iPhone!). And speaking of computers, whether at home or the office, you're more likely to use portable laptops instead of plunking down in front of one of their bulkier cousins, those desktop real estate-hogging workstations, commonly used by most of us not so long ago. It's not just size and portability that differentiate the majority of computers in use today from their recent ancestors. Most computers that are used today are linked together—as well as to servers, printers, and other digital devices—via wireless networks rather than wired connections. And it's not just that mobile devices and wireless connections keep you hyper-connected, you're also likely to be connecting with, working via, and collaborating through virtual devices that you have no physical relationship with at all. You're just as likely today to backup your important digital data online as you are to a dedicated device that is physically attached to your computer. You're able to collaboratively create detailed text documents, spreadsheets, or visual presenta-

> New media afford you the opportunity to engage with content in novel ways, ones you simply didn't have access to in the past.

tions using "cloud" apps that run in a browser window rather than through software applications that are installed on the hard disk of your computer.

As noted earlier, the times they are a changin'! We've actually made great leaps from the earlier days of the digital media revolution where issues of convergence were of principal concern. That was the early era of the digital revolution when the shift from old media to new media was more painfully apparent. During those days, media producers were largely concerned with thinking about ways that new technology would allow them to distribute content of multiple types via multiple channels at the same time. The Web afforded content producers the ability to offer a wide variety of media forms—print, photography, video, animation, graphics, etc.—in one package and deliver it to the intended audience on a variety of platforms, the World Wide Web at the time was the most obvious.

That's pretty much what happened. As the Internet rose to become a dominant player within the plethora of media options available, producers found ways to leverage the technology toward delivering more content.

That's pretty much what happened. As the Internet rose to become a dominant player within the plethora of media options available, producers found ways to leverage the technology toward delivering more content. A headline story appearing in the Sunday edition of the *New York Times* might be relegated to two, maybe three photos at most, but the Web-based version of the same story might contain fifteen to twenty. Information graphics were no longer fixed in static formats but could be animated or presented in the form of a step-by-step slide show of the relevant data.

Today, we've moved past the point where convergence is the dominant concern. Convergence is more or less assumed at this point; it's simply part of the medium. Consumers now find themselves immersed in a more mature and sophisticated media landscape. Relevant technologies, and their uses, have matured. Of course, digital is still the name of the game, but the possibilities have multiplied; the potential for interactivity is greater than ever before. Users have become the great contributors of much of the Web's content in stark contrast to the role of simple consumer that most were relegated to not long ago. The popular YouTube Web portal alone illustrates this point. Social media platforms and blogs provide audiences with the means to stay connected and to contribute content. Data-driven content management systems, the backbone on which many of the most information-rich Web sites are now built,

allow content authors a way to distribute information without needing to understand the technical intricacies of Web development. "Web 2.0," a term that generally refers to Web-based applications and platforms, makes it easy for users to collaborate, share, contribute, and author their own content, and is responsible for decentralizing the locus of content available to consumers like you.

Whether you realize it or not, you've picked a thrilling time to learn about digital content production. Technology is evolving at a break-neck pace which, more often than not, is creating a great amount of potential for you as a content producer. You now have the opportunity to produce content for your client or employer—or for yourself for that matter—and disseminate that information to a very broad audience. You have much greater control over the entire process. You might choose to be a writer, a photographer, a designer, or a filmmaker; in all actuality, the professional world that you're about to enter will probably ask you to be all of these and more. You're also preparing to enter the digital media profession at a daunting time, one full of new technologies and the complexities they entail. The career you pursue will be both exciting and complex.

> You might choose to be a writer, a photographer, a designer, or a filmmaker; these days the professional world that you're about to enter will probably ask you to be all of these and more.

Technology will in many ways define the choices that you make and the directions you take. Though it will be challenging, it's an exciting time to begin a career in visual communication, one rife with opportunities for you to exploit.

How Are They Different?

Pretty amazing stuff, don't you think? As you dig a bit deeper into the topics at the core of this book—ones that will prepare you to become a producer of sophisticated digital media—you need to accomplish two objectives: 1) You need to understand the place in which you find yourself presently situated within the overall media landscape, and 2) You need to realize what it is that you're either actively doing or that you have the potential to be doing with all of this digital media.

To set the stage for the chapters that await, let's address the question of what you need to know to become a savvy producer of non-linear, bi-directional, interactive content. Before you begin to figure out the major differences between old media and new media,

you'll need a clear picture of what these terms mean as they deter-mine most of what's different. In actuality, these terms are rather simple—how complicated can the words non-linear, bi-direction-al, and interactive really be? How these terms are applied to the cre-ation and consumption of media isn't that complicated, either, but having a solid grasp on what they mean will be key to understand-ing the big picture of the media evolution from old to new.

Old media are predominantly linear. At the simplest level, lin-ear media can be defined as media that have a deliberate beginning and ending. The information is delivered to you in a chronological structure. With linear media, you don't normally jump from the be-ginning to the end and then to the middle, but instead absorb the information from a defined starting point to a clearly communicat-ed conclusion. A novel might start with chapter one and conclude with chapter eighteen; along the way you read the in-between chap-ters in sequential order. Likewise, a film usually starts with an open-ing title sequence and ends with the closing credits. The bulk of the story occurs chronologically between these two events. Television programs, whether we're talking about a weekend sports event, a prime time drama or the evening news, work the same way.

New media, on the other hand, don't always work that way. Think of a video game. Most have a story full of interesting char-acters, but they don't necessarily tell the story of those characters in any chronological fashion. The story is unveiled in bits and pieces as the game is played; it's just not told in a normal linear progres-sion. User interaction with the game dictates how and at what pace the story is revealed. Two different people playing the same video game will eventually realize the same story—provided they both play long enough—but they most likely won't get there in the same way.

> Media such as film, television, radio, etc. are all uni-directional in the sense that your consumption of the media is like driving on a one-way street.

This leads to the second compo-nent of old media: They're uni-di-rectional. Media such as film, television, radio, etc. are all uni-di-rectional in the sense that your consumption of the media is like driving on a one-way street. As you watch your favorite sports team compete on television, though you may yell at the screen in joy or agony depending on how your team is playing that day, your ac-tions don't affect the delivery of the information; it keeps flowing down that one-way street no matter how you react. When you lis-ten to a radio talk show, you act solely as a receiver. In these exam-

ples, the flow of information is always in one direction: from the source to you.

New media, on the other hand, ask users to get their hands dirty. The flow of information is bi-directional: a two-way street. Information is delivered to you, and you respond. You can't play a video game unless you're willing to, well, play. You can't consume the content on most Web sites unless you're at least willing to click a few buttons. Blogs don't just deliver a writer's views on any number of topics, they also allow you to participate as a commenter. Wikipedia is dependent on users to contribute and edit content, not just consume it. Social networks such as Facebook or Twitter exist only through the direct involvement of users; without users there wouldn't be any network, social or otherwise! All of these types of media provide some amount of informational content while allowing for your participation. The most robust new media—more often than not, those types that have been designated as "Web 2.0"—often simply provide platform and structure while users dictate and drive the content.

> The most robust new media often simply provide platform and structure while users dictate and drive the content.

Finally, the simplest term of the three is interactive. Old media aren't terribly interactive unless your idea of interaction involves easing back into a comfortable sofa with a bowl of popcorn as you watch your favorite feature film. Old media beg only one thing of you: your attention. Think about the last time you watched a show on television. About the only thing interactive that you did was to adjust the channel to a particular station or change the volume. New media are quite the opposite when it comes to interactivity. While old media barely play the game of interactivity—if at all—new media is the team to beat. Want to respond to an article about your favorite sports team? Many Web sites allow you to, but to do so you've got to be willing to interact. Want to share your photographs with family or friends or maybe the world at large? There are sites dedicated to letting you do just that. Want to know something about a particular topic? Check out a wiki where you can also contribute if you so choose. None of these activities would be possible if the provided media weren't interactive. Think of it this way: most old media are like a monologue. It's delivered; you listen. New media are like a conversation. They're interactive because of your involvement; the conversation ceases to exist without your participation.

Like most things, there's a wide range of quality when it comes to new media. That said, new media that are really good generally do at least one thing well: They provide users with a large selection of content delivered via multiple outlets using an array of media formats. Though somewhat dated, the catch-all term "multimedia" really is the most accurate descriptor to apply to this type of information. A well-designed and carefully thought-out Web site not only delivers text and images but might also provide video, photo slide shows, maybe an interactive map or timeline, or possibly a database-driven graphic that pulls dense information content from an external source.

Most of What You Need to Know Hasn't Changed!

Okay, first the not so good news: Delivering content through the same old channels isn't enough to satisfy today's generation of savvy consumers. Developers of old media must adapt their practices to match a changing marketplace. Clearly this is due to the rise of many forms of new media and the ways by which those media are produced. Newspapers and newsrooms must either think outside the box when they consider how to reach their readers or risk losing traction to media companies that will. The printed word is still a favored medium, but it's by no means the sole method that consumers consider when looking for content. Producers of both films and television programming must contend with a much wider array of audience choices when it comes to the consumption of the content they provide.

> As a producer who is developing new media content destined for Web sites, mobile devices, and the like, you need to possess plenty of old media skills.

Gone are the dominant—big three—television networks; the success of cable television has seen to that. When it comes to film, there are many new options for distributing content to audiences including traditional theatrical screenings but also straight-to-DVD offerings, television pay-for-view, Netflix, Redbox, and films streamed from a variety of Web-based sources. The new players in the game are so successful that they seem to have dealt a mortal blow to the bricks and mortar video rental stores that until very recently were commonly found in virtually any location boasting a modest population. The list goes on.

Given that, what types of skills and knowledge do today's content producers need to possess? A mixture consisting of a handful of old skills and a smattering of new moves is a glib but pretty ac-

curate answer. As a producer who is developing new media content destined for Web sites, mobile devices, and the like, you actually need to possess plenty of old media skills. If you stop and think about it, most of the skills that you'll need as a developer and producer of new media content really haven't changed that much. A lot of what you need to know about how to create engaging content is rooted in the same core sets of skills that media professionals have been utilizing for many, many years. You need to have a good eye for visual aesthetics; you need to know how to create and manipulate both static and time-based imagery; you must understand the basic components of graphic design like typography, color, and layout; you must possess the ability to shoot photography and video and then edit it into meaningful content; and you need to have an understanding of narrative structure and storytelling.

If you're a seasoned professional, you already know the majority of what you need to know to thrive in the current media environment. If you're new to the game, then make sure you pay attention to the old skills regardless of what you intend to do with them. Whether you use those skills to inform, entertain, or educate, you'll still rely on the timeless value of well-written copy, striking photography, inventive graphics, and persuasively edited video. Storytelling skills were, still are, and most likely always will be extremely valuable no matter what delivery mechanism is being implemented to deliver the finished narrative. Developing and honing these skills will always be important regardless of the end product that you're creating. To borrow a metaphor from baseball: Keep your eye on the ball, which, in this case, is the development of engaging content. Without good content, it really doesn't matter that much how sophisticated or slick the delivery mechanism is.

What's different—really different—is actually quite simple, at least at the structural level. The main difference deals primarily with the mechanisms through which content is delivered to an audience. Moving forward, more often than not, you'll be creating content for new media delivery systems and will thus need to appreciate the specific nuances involved with doing so. Most of the time this will incorporate developing content that is online, ubiquitous and available to everyone.

Being a content developer for new platforms that implement new technologies certainly requires that you master a set of new tools and techniques. The toolset isn't huge (unless you want it to be), but it is important.

Though it may not sound all that appealing (or maybe it does if you consider yourself fairly technically adept), you're going to need to become somewhat proficient with writing programming scripts and markup code. You won't need to possess the skills required to actually create full-blown software applications from scratch, but you will need to understand something about the way that Web sites are structured to display content. Today, this means having some proficiency with reading, writing, and editing HTML (Hypertext Markup Language) and CSS (Cascading Style Sheets). Having a few skills with technologies such as Flash ActionScript, Javascript, and PHP certainly wouldn't hurt.

> Being agile and adaptable as relevant technology matures or is even replaced is as valuable a skill as being adept with any current mainstream toolset.

As valuable as it is to understand any number of Web development technologies—usually the more, the better—it's also important to recognize that you're embarking on a career in a profession that's constantly in flux. What's essential today might be passé tomorrow. Being agile and adaptable as the relevant technology matures or is even replaced is just as valuable a skill as being adept with any current mainstream toolset. Accepting the fact that technological innovations cause changes in the tools that you'll use and in the platforms for which you'll create is ultimately an essential realization that you need to make. Remember, though, that even when it seems that the next great technical gizmo set to roar down the pike will surely overwhelm you, your knowledge of old media production processes will always be important. Good design is good design regardless of where or how it is manifested!

So what does new media really mean for you as a content producer? It means that as you develop the necessary content you do so with a few new considerations in mind: What opportunities do the tools and techniques of interactivity afford you as a content creator? How can interactivity change the way you tell a story? How does the interface that sits between your audience and the content you want them to digest affect their ability to do so? What does providing content to an audience who can access it at any time mean in comparison to delivering content at predefined specific moments in

time? Those are just some of the meaty questions that you'll want to ponder once you have some of the more basic content production skills under your belt.

What Does the Future Bring?

What challenges will the various media types of the future present to you in your role as a visual content producer? What types of future technological developments—and the impacts those developments will surely have on the media landscape—will you have to contend with as you begin your career? Nothing is guaranteed, but here are some good bets for what's coming around the corner in the near future.

The rise of a semantic Web—sometimes referred to as "Web 3.0"—is a hotly debated potential development that professionals in the know have been anticipating for some time. A semantic Web is one in which Web sites inherently understand what the content they are displaying actually means and can, therefore, do something intelligent with that knowledge. A semantic Web would allow content producers to more easily create and distribute useful information. In simple terms, a semantic Web is one that incorporates a language that machines can understand. In the case of the Web, machines primarily refers to computers—including Web servers—that will be able to find, present and execute specific tasks with the data that's made available to them.

> In simple terms, a semantic Web is one that incorporates a language that machines can understand.

A good example of a semantic technology that will have an effect on the way we use the Web is Friend of a Friend (FoaF). FoaF technology uses defined information about an individual person to link that person to someone else. Current Web platforms and applications such as Facebook and LinkedIn already use similar technologies to make friend and business associate recommendations.

Artificial intelligence (AI) is a technology that's related to aspects of the semantic Web and one that's been anticipated for an even greater amount of time. AI is steadily becoming a useful technology—not just a sci-fi-laced portent of the future. AI is actually being robustly incorporated today by an exciting form of new media: video games. Most complex video games leverage artificial intelligence—built into the game engine which is the programming code that acts as the brains of the game—for the primary method

by which the game system makes decisions and responds to the interactions of players. The difference between AI and semantic Web sites is that AI is built to truly parse and understand the presented information and then do something meaningful with it. Semantic Web sites and applications on the other hand are able to act on a given amount of information by the way in which those data are structured and by the rule system by which the data are governed.

AI technologies seem poised to have the greatest effect on media in which storytelling and narrative are the primary features. Building upon what video game developers have achieved with AI, we're likely to witness the mainstream arrival (this type of work is already being created in bits and pieces) of interactive films, documentaries and television programming as dominant components of our future media smorgasbord. The ascent of this type of media would obviously create all types of new opportunities for content producers, especially those who are adept at creating and manipulating visual imagery in the context of a greater narrative.

> The future will bring with it the occurrence of ubiquitous, user-generated content in larger amounts than what is available today.

It's very likely that magazines, newspapers and other periodicals will offer their content primarily through online distribution channels; few, if any, will remain predominantly in print. Micro magazines, those devoted to a niche topic—such as say beach volleyball or Thai food—with a small dedicated readership, will likely become the norm. As advertisers will likely support the transition to micro formats, periodicals dedicated to broad content areas may simply not be able to compete. Micro magazines will offer targeted opportunities for advertisers to get their messages to the consumers they most want to reach—those with a clear affinity for certain topics and related products and services.

In addition to these developments, you can count on more of some types of the technological advancements that are transforming today's media landscape, such as mobile devices and applications as well as collaboratively created content. Consider how the iPhone has changed the media landscape in such a short amount of time. What's next to change now that we have the iPad on the scene? Surely the publishing industry is pondering this with more than passing interest. The future will bring with it the occurrence of ubiquitous, user-generated content in larger amounts than what is available today. Intelligent mobile devices are already allowing us-

ers to stay connected from anywhere at any time of day or night. Imagine the nature of media—including the opportunities that will be available to content producers—when most people are equipped with such devices. It doesn't take too much intelligence to reason that there will be a great need for content. In the future we will see the shift from media that are relatively slowly delivered and general in nature to content that are fast and very specific. We'll experience and use more media on our handheld devices than we will on any fixed device, be it a laptop computer, television or fixed workstation. Intelligent applications will allow our devices to execute many of the tasks that we do ourselves now. The need for content of all types will increase dramatically, thus creating numerous opportunities for content producers like you.

2

The Power of the Image

As an introduction to this chapter, let's start with an anecdote. A couple of years ago, one of the authors of this book and his wife traveled to IKEA, the Scandinavian home furnishings mega-store. They bought their children, who were four and six years old at the time, a table with chairs for them to use as an art table. This table is small, round, brightly colored and made of plastic. Like many things purchased these days, some assembly was required. Inside the boxes that the table and chairs were packaged in was a tabletop with five unattached legs and four chairs separated in parts comprised of seats, backs and legs. Well, obviously, some instructions were needed! As expected, they were included in the boxes of parts. What was unexpected was that the instructions for both the table and the chairs were two sheets of paper—two simple, 8.5" x 11" sheets of paper! Furthermore, neither of the pieces of paper contained any text elements outside of the IKEA logo. There were no written instructions whatsoever.

The instructions for putting the table and the chairs together were delivered completely in picture format. Images and diagrams were used to explain the entire assembly process. Somewhat skeptical of this instructional strategy, the couple realized halfway into assembling the first chair that they didn't need any text; the images were sufficient. This is interesting for two reasons: 1) IKEA made the realization that images often speak as well or better than words. The table and chairs went together without any problems; in fact, it's quite conceivable that words might have complicated the process. If, for no other reason, text would simply have taken

KEY TERMS

alignment

area

camouflage

closure

common fate

continuity

eye tracking

figure-ground

gestalt theory

patterns

positive-negative

proximity

semiotics

similarity

usability

visual hierarchy

longer to digest than it would to process the images. 2) The instructions were delivered without any need for text. Yes, we know, we've already stated that. But think about it for a minute. IKEA is an international company. Its products are sold in many places around the world through bricks-and-mortar retail stores and through an online catalog. Normally, a company that sells their wares internationally that require you to assemble or sometimes even use their products will provide an instruction manual with the product that is translated into a large selection of languages. Furthermore, the typical instruction manual is often comprised of numerous pages. The thickness of many instruction manuals is due largely to the simple fact that the relevant information must be replicated in multiple languages. In stark contrast to the norm, the instructions from IKEA required only two sheets of paper that were accessible and understandable by all.

In this example, images were used to effectively communicate a step-driven procedure quickly and accurately. The use of images enabled the manufacturer to transcend the need for written text—in one or more languages—and to simplify the communication of a reasonably complex procedure into a set of simple illustrations and diagrams. We're hard pressed to choose a better example that communicates the power of imagery. However, we'll give it a shot.

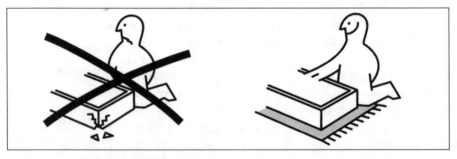

Figure 2-1: IKEA assembly instructions

Imagine you're an American graduate student studying abroad in the Czech Republic for six weeks. Traveling and living in a foreign country where you don't speak the language is a wonderful opportunity for realizing the limitations of a written language. Living in Prague on a student's budget means that several visits to the grocery store will likely be necessary to keep you fed. Assuming that you're like most people and not on overly adventurous eater, you're

probably not much inclined to buy any product in a Czech grocery store if you're not first able to determine what exactly is contained inside the package. Since most food products are packaged—almost everything for sale in a grocery store except produce—then you'll naturally need to rely on label imagery to tell you what's inside. If the packaging contains only textual elements, then you might decide to skip that food item. Given that you're on a budget, you probably don't want to spend money on a food product only to find out that it's something that you aren't willing to consume.

In this case, the reliance on imagery equates to survival. While that statement may be somewhat overly dramatic, the simple fact is that if you're studying or living abroad, you might be somewhat reluctant to buy a food item if you cannot first determine what it is, its ingredients, or how it is prepared. Being completely illiterate in Czech (the native language) you would be forced to rely on imagery for the information that you need. Whether that imagery incorporates photography or illustrations, you will likely need something visual to propel you to make a purchase. Luckily, most grocery stores sell food items that possess packaging that offers at least a small hint of what lies in wait on the inside. Thank the stars for images!

If you need more confirmation that we live in an image dominant world, just think of any time that you've traveled to a foreign country and been in a car or bus. Whether you were actually driving or not, its easy to appreciate the need to comprehend basic traffic signs in order to arrive safely at your destination. Thankfully most places in the world use simple illustrations as a primary component in the design of traffic signage. Given this scenario and the preceding anecdotes, it's not hard to see that we often greatly benefit from and are sometimes utterly dependent on visual imagery or instructions, directions, and basic communication. Okay, enough with the anecdotes. Hopefully we're in agreement that visual imagery is a powerful medium for, among other things, a wide range of communication

> One of your initial challenges in learning to become an effective visual communicator is to gain an understanding of the way your mind makes sense of what your eyes see.

tasks. Just in case, you're not convinced remember the age-old adage (that many attribute to Napoleon Bonaparte) that you've certainly heard before: a picture is worth a thousand words. If this saying is even partially true, then why? What aspects of brain function are responsible for our ability to form meaning from a visual image almost immediately? In the rest of this chapter we'll explore how the

mind and eye work together to drive our visual perception abilities toward meaningful experiences.

Every day you're confronted with an enormous amount of visual stimuli. You make sense of this overwhelming amount of information by paying attention to the things that you need to see and ignoring the rest. One of your initial challenges in learning to become an effective visual communicator is to gain an understanding of the way your mind makes sense of what your eyes see. What techniques does your brain employ to turn visual sensory information into something meaningful? By understanding why you pay more attention to certain visual information than you do to others or why you categorize what you see, you will be able to leverage this knowledge as you attempt to create effective visual communication artifacts. In your efforts to become more aware of the cognitive aspects of visual perception and how they inform your creative process, you will need to examine several principles and theories of visual perception including gestalt, semiotics, figure-ground relationships and more.

> Gestalt psychology describes a set of visual perception theories concerned with how your brain perceives what you see with your eyes and makes meaning from the resulting images.

Gestalt Theory

The word gestalt means "organized whole." Gestalt psychology describes a set of visual perception theories concerned with how your brain perceives what you see with your eyes and makes meaning from the resulting images. In the simplest definition, gestalt theory describes the ways in which your brain is inclined to arrange what you see when interpreting visual information into meaningful groups. Another simple way to describe this effect is that your brain strives to organize what you see with your eyes into distinct patterns of visual information. Gestalt theorists have determined different laws or theories that describe several related but separate reasons for how and why your brain tends towards this pattern-making/grouping effect. As we explore the concept of gestalt further, keep in mind that these theories are based purely on what objects look like and not on anything specific to their true nature or intellectual meaning.

When you read printed writing, you digest words instead of letters as you attempt to derive meaning from the text that you read.

You do not read letter-by-letter but rather word-by-word. Each word that you read becomes a unique form representing the entity that it describes. Gestalt theory says that the reason you read words as wholes instead of their component parts—letterforms—is because your brain's first tendency is to group words based on proximity (one of the principles of gestalt theory). If the words in a sentence or paragraph contained no spaces you'd cease to see unique word forms. In a sense, the spaces in a sentence—though meaningless in and of themselves—are as important to your ability to understand what you read as the actual words are. Thus, the gestalt phenomenon in the case of reading is based on the principle of proximity. Because a word is a simple arrangement of letters in close proximity to one another, we come to recognize it as a unique entity.

> When you look at something and try to make meaning of what you see, you tend to interpret the sum of the parts—a grouping effect, if you will—rather than the component pieces.

When you look at the face of someone you know well, what do you see? What does your brain translate for you from the image of a person before your eyes? You see that person, of course. Yet there's no denying that if you examine your friend's features, you also see the component parts that make up that person's face: nose, eyes, mouth, ears, hair and so on. Again, the principles of gestalt tell you that when you look at something and try to make meaning of what you see, you tend to interpret the sum of the parts—a grouping effect, if you will—rather than the component pieces.

Think a scene in which you see a flock of Canada geese traversing the sky on their way to some watery destination. Yes, you certainly see a number of geese flying together, but you also can easily see a "V" that comes from the particular formation in which the birds usually fly. The gestalt principle of continuity is at play in this example. As you look at the formation of geese, you tend to see a continuous line of birds that make the shape of a "V." Or envision lying on your back, gazing at the sky and trying to find images in the clouds. On the one hand, you clearly know that you're looking at a sky full of clouds, but it doesn't take long to start to see all sorts of recognizable forms emerge from the swirls of atmosphere. You're sensing patterns in the morass of visual information that you form into something that has meaning such as the image of an animal or a person. Though these are simple—but very common—examples of gestalt, they easily communicate the fact that your brain is constantly making meaning of what you see. In doing so, you are often

ignoring the true nature of individual component parts and are interpreting—through grouping and pattern making—what you see as something altogether different.

The overall concept of gestalt is comprised of several unique principles, all of which describe different ways that your brain interprets visual phenomena. The following are the usual suspects that emerge in a discussion of gestalt: closure, similarity, proximity, continuity and common fate.

Closure

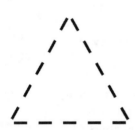

Figure 2-2:
Closure

The principle of closure illustrates how your brain is able to fill in missing information needed to completely describe what you see (as long as there is enough information available). Your brain exercises this principle all the time. Think of how often you look at objects, say someone's house, and fully understand what you're observing even though one or more objects may obscure your view. As you look at the structure, it's virtually a given that you'll be confronted with a view that contains many obscuring objects, such as trees, that prevent you from seeing a complete, unimpeded image of the house. Nonetheless, you still see a house and interpret the visual information as such.

As a simple example of the principle of closure, look at the shape in Figure 2-2. Although the shape is missing some amount of information, your brain is still able to supply the missing information needed to complete the triangle. Your mind is very good at closing the gaps in an image by filling in the missing parts.

Now consider the figure in Figure 2-3. Again, even though information is missing, you have no problem determining what each letter in the word is as well as the word itself. Your brain "closes" each form by filling in the missing information.

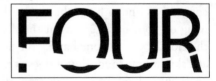

Figure 2-3: Closure

Similarity

When you see things that are similar in appearance you tend to place them into groups. Similarity is the

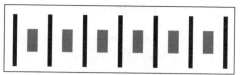

Figure 2-4: Size

gestalt principle that describes this phenomenon. Likewise, when you view a set of items that are dissimilar, then you tend not to group them. Your brain organizes what you see by grouping items that are similar to one another via comparisons in size, shape, style, tone, or color.

The image in Figure 2-4 shows two groups of rectangular shapes. Though there are thirteen rectangles in all, you tend to see a group of black rectangles and a group of grey rectangles. The principle of similarity says that this happens for two reasons: the grey rectangles are similar to one another in tone and they are similar in size (or scale). The same is true with the grouping of black rectangles: they are similar in tone and size. Even though all thirteen shapes are rectangles—which certainly makes them similar—your brain sees two unique sets of rectangles and puts them into separate groups.

A similar effect can be seen in Figure 2-5. In this arrangement of simple shapes, the groupings are based on shape. You perceive the squares as being in one group while you see the circles as being in another. Even though the similar shapes are separated from one another by the opposing shape, you still tend to group them according to their similarities.

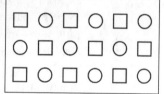

Figure 2-5: Shape

Similarity grouping effects might also be achieved via the manipulation of stylistic features as they are in the image at right. In Figure 2-6, a clear grouping can be made based on the two tones used to fill the triangles. Furthermore, separation into two groups can be made based on the black outline used to stylize half of the triangle shapes. Even though there is a grouping effect that separates the total arrangement of shapes into one group on top and one on bottom (based on the principle of proximity), you can also easily separate the shapes into two distinct groups based on the different styles applied.

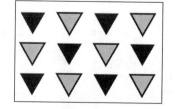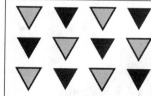

Figure 2-6: Style

Proximity

The theory of proximity describes how you tend to place items that are close together into groups. Simply put, the closer two items are to one another, the more likely you are to interpret them as a group. The potential for viewing separate items as a group becomes even greater when physical proximity is combined with larger numbers of items.

For example, in Figure 2-7, you see three sets of two squares. When the squares are close together, you readily view them as a group but when moved apart you eventually perceive them as separate elements. In the illustration, the pair of squares on the left is easily perceived as a group whereas the pair on the right is not. How about the pair in the middle?

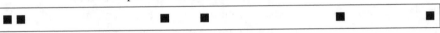

Figure 2-7: Proximity tells us that the two squares at left are related.

In Figure 2-8, there are nine squares in each of the three groupings. In the arrangement on the left, you tend to view eight squares as being part of a group. (The group actually looks like a cross or plus sign—this effect is achieved via one of the gestalt principles that we just explored, closure!) Conversely, the ninth square, the one in the upper left of the first grouping, is viewed as a singular element. It is not part of the group. In the middle arrangement, you perceive all nine squares as being part of the same group. By moving the solitary square on the left into proximity with the other eight squares, you are now able to visually perceive it as being part of the same group as the other eight squares. On the right side of the figure, you see a vertical grouping of five squares which was achieved by moving four of the nine squares—the two to the left and the two to the right—further away as well as through the close directional proximity of the five remaining squares. This illustration also demonstrates a sub-concept of proximity: alignment. Alignment dic-

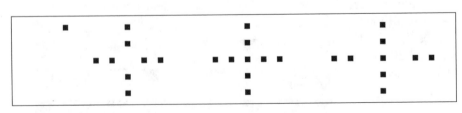

Figure 2-8: Placement of the far-left square suggests it does not belong.

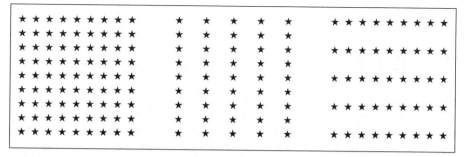

Figure 2-9: Different alignments make three distinct effects.

tates that when you observe items that are in spatial alignment with one another, you tend to place them into groups.

Figure 2-9 further demonstrates the alignment component of the principle of proximity. On the left side, you see the arrangement of star shapes as a single group. However, in the middle illustration and the one on the right, when select rows or columns of stars are removed you tend to see either vertical or horizontal groupings of shapes.

Continuity

The gestalt principle of continuity attempts to describe how your brain is willing to see something as continuous even if it is just suggested. Your mind strives to create continuous form as long as there is continuity in the direction in which a particular form or shape is traveling. In Figure 2-10, you perceive the image to be either a cross or plus sign or at the least as two continuous line segments. What you don't tend to see are four independent line segments that happen to share an endpoint. If you think about it, though, it's entirely possible that this is indeed the case. The principle of continuity describes this phenomenon and the tendency that our brains have toward continuing any form or shape along the path that it is naturally traveling.

Figure 2-10: We see a plus sign rather than four segments.

In Figure 2-11 on the next page, your mind tends to interpret each of the four illustrations differently. In the first illustration, you see two distinct curves: path WY and path XYZ. You perceive two separate curves because the principle of continuity dictates that you want to extend a line, curve or shape as long as it continues to flow in a given direction—in this case your mind extends path XYZ because it is flowing in the same general direction. In the sec-

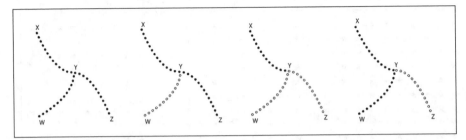

Figure 2-11: The principle of similarity can interact with how we view continuity.

ond illustration, you perceive the same two separate curves, however this time the fill and outline of the WY path are treated differently. (Your perception of continuity is strengthened because of the additional principle of similarity—via tone—at work.) In the third and fourth illustration, you see two different curves—XY and WYZ. In the last illustration, you arrive at a perceptual conflict. Your new friend, gestalt, is to blame. On the one hand, you want to see two separate curves that are delineated by their tone: XYW and YZ. However, we also tend to see curve XYZ as being a continuous curve because of our propensity to continue the curve as it moves from point to point. Essentially, the perceptual conflict in part D can be blamed on the tug of war going on between the gestalt principles of similarity and continuity

Common fate

The gestalt principle of common fate suggests that items that move together, items that demonstrate the same function and/or behavioral patterns or items that point in the same direction are perceived to be in the same group. For example, assume a crowd of people at an outdoor concert. You see the entire crowd as a group because of the principle of proximity (discussed earlier in this chapter). At some point in time, five friends who are attending the concert together, and who are members of the larger crowd, leave the venue at the same time. They all move in a similar direction as they head for the same exit. As they make their way toward the exit, you perceive them as a group because they are moving together; they are ex-

> Common fate suggests that items that move together, items that demonstrate the same function and/or behavioral patterns or items that point in the same direction are perceived to be in the same group.

hibiting the same behavior. This is due to the principle of common fate.

Common fate can be applied to items that point in the same direction and to items that behave or function in a similar manner. Elements that move together in the same direction are perceived as being more related than items that are not moving or that are moving in different directions.

Figure-ground relationships

Figure-ground relationships, also referred to as positive-negative space, describe how your brain tends to see things as either primary elements or background information. In this way of thinking, it's sometimes easier to think of figure-ground relationships as helping to define and separate foreground elements from background information. Figure-ground relationships define one way that you can discern form in what you look at.

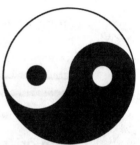

Figure 2-12: The concept of figure-ground.

When defining and describing figure-ground relationships and how your brain makes sense of them, it is necessary to discuss the principle of area (sometimes included in descriptions of gestalt theory). Definitions of area say that that the smaller of two overlapping areas will be understood as representing figure, and the larger area will be viewed as representing ground.

In Figure 2-12, you see a well-known symbol, the yin-yang symbol that originates from Chinese Taoism. In each half of the symbol, you can observe simple figure-ground relationships based on the principle of area. In the black half, you tend to view the small white circle as being the figure and the larger black area as being the ground. In the white half, you comprehend the visual information the same way (though the colors are reversed): the small black circle represents figure while the larger white area represents ground. It's often helpful in simple examples like the yin-yang symbol to think of figure-ground as simply meaning foreground and background where figure equals foreground and ground equals background.

The exploitation of figure-ground relationships can be of significant value when designing graphic images such as

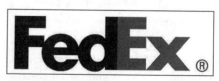

Figure 2-13: Figure-ground in a corporate context.

logos. Take a look at Figure 2-13. You should see a well-known logo, one that you have little trouble recognizing. Do you see the arrow, though? Look closely; even if you've never noticed it before, now that you are prompted to search for it you shouldn't have much trouble locating the arrow. It appears completely in the negative space of the image. The arrow embedded in the Federal Express logo is an excellent example of how the manipulation of positive—negative space in the design of a corporate logo can be very effective.

The concept of camouflage—something that acts as a disguise—works because we have difficulty discerning the differences in figure and ground in a scene where camouflage is used. This happens because the use of camouflage merges what we interpret as figure versus ground, effectively blending foreground elements into the background. Figure-ground relationships provide the brain with information that it uses in one of two ways: to either enhance or obscure the visual meaning in a particular scene or image. In the case of camouflage, it's the latter of these two possibilities.

Semiotics

The study of semiotics explores the use of symbols as communication devices. You regularly interpret symbols that you encounter in your daily life. When you see the U.S. flag flying, you don't normally interpret that as a flag made of red, white, and blue fabric. Instead, you view the flag as a symbol of the United States of America. You might also attach further meaning to the symbol depending on the greater context in which you interpret the flag: you may see the flag as a symbol of the federal government, of the country as a whole, or as a symbol of support for a particular war. Regardless of the specific interpretation, the actual flag flapping in the breeze at the top of a pole acts as a symbolic mechanism full of strong and potent meaning.

Whether you're aware of it or not, you possess sophisticated abilities that you use to parse meaning from symbols and representations, even ones that border on the abstract.

You receive and interpret semiotic elements as a regular part of your daily life. You constantly interact with signs and symbols that act as vehicles of meaning. You regularly make sense of semiotic devices as simple as mathematical symbols, such as the "$=$" sign in an equation, to more complicated representations of global corporations, like the Nike Swoosh logo, or even symbols of sovereign nations, like the hammer and sickle that once represent-

ed the might of the Soviet Union. In reading an article in a newspaper or magazine that details the famine in a foreign country, you are likely to be presented with a photo of a malnourished child. Obviously, the story is about a larger group of people than one unfortunate child. Given that, how could such a simple image represent the suffering of a multitude? Easily: the photograph is a basic semiotic device that acts as a symbolic representation of something much more complex. It would clearly be difficult or impossible to demonstrate, in a literal fashion, the suffering of so many in a photograph. However, by using an image of a single child the editors are able to powerfully suggest the plight of many.

As a consumer of visual media, you interpret semiotic devices constantly. Whether you're aware of it or not, you possess sophisticated abilities that you use to parse meaning from symbols and representations, even ones that border on the abstract. As producers of visual media, you can take advantage of this fact. As you design and produce visual communication artifacts, you can and should rely on the inherent sophistication of your audience and their innate understanding of semiotics.

Patterns

Our minds tend to like patterns and are very good at making sense of them and converting the visual information into meaning. Gestalt psychology tells us that we strive to organize visual information into meaningful patterns rather than perceive that information as distinct parts. This is one way that you make sense of what you see. When you view a repetition of elements you see the components as a continuum of visual information that you define as a pattern. This is somewhat obvious if you consider something like the pattern represented in the mosaic image to the right. Though the overall artwork is made up of an arrangement of tiles, you are able to easily recognize that there is an image of a flower represented. Your brain allows you to view the arrangement of tiles as a holistic design—not the individual parts that make up the design—that represents unique information presented in a defined pattern.

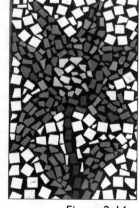

Figure 2-14: **Pattern in art.**

Your ability to recognize and make sense of patterns becomes more complex when you consider organic patterns such as those presented to us in nature. Considering the image

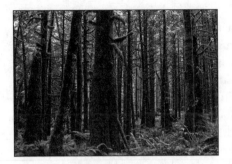

Figure 2-15: Pattern in nature.

at right, most would agree that the subject matter is a forest though it's easy to see that the photography is comprised of a large number of individual trees. Your innate ability to perceive patterns allows you to quickly move past the individual elements in the photograph and transform the meaning they represent as a group into something larger in context, in this case, a forest.

As a digital content producer, having an appreciation for the innate ability that human beings possess when it comes to recognizing patterns in everything, including text and images, will allow you to design visual content that is both easy to use and yet sophisticated. The incorporation of patterns in visual design elements allows end users to cognitively arrange the content into meaningful sets of information. Patterns should inform the design of everything from navigational elements found on a Web page to motion graphics typography used for a commercial advertisement.

Visual Hierarchy

The concept of hierarchy is important to consider when designing content that will be delivered to an audience. Just like the theories of gestalt discussed earlier in this chapter assert, your brain likes to organize elements based on perceived importance. One way to control for this innate tendency is to consciously arrange designed content in terms of value or significance. Visual hierarchy provides users with a sense of order and an understanding of ranked value.

If you think of the front page of any newspaper, the most important articles are always given the largest headlines. The large headlines tell the viewer that a particular story is the most important item on the page. As the size of headlines decreases so does the importance of the accompanying story in relation to the rest of the page's content. This is true of non-textual elements as well. Think of a layout that makes use of photography like the one in Figure 2-16 from the entertainment section of the *Los Angeles Times*. Clearly, one of the featured entertainment stories stands out in relation to the other articles. This is communicated to you by the fact that one of the photographs is larger in size in comparison to the other im-

ages. Your brain interprets this arrangement to mean that the larger photograph is more significant than the others in the layout, and, by extension, the associated article is also more important.

When you are designing visual elements, you can control the hierarchy of information through the manipulation of basic design features such as scale, weight, value, color, and spacing. Doing so will allow you to guide your users' attention in ways that facilitate their ability to create meaning from the content that you provide. For instance, think about a Web site that you frequently visit or a magazine article that you read recently. Was any of the text on the Web site or in the article larger than the rest? Was any text item set in a bold typeface?

'Glee' is music to songwriters' ears
By Scott Collins and Denise Martin, Los Angeles Times
Pop classics have been getting a sales bump after being performed on the Fox series "Glee" Steve Perry cheers. But not everyone is...

- Is 'Glee' doomed to lose best comedy series at the Emmys?
- 'Glee' hoping for more Madonna?
- Big Picture: Is 'Glee' part of Hollywood's leftist propaganda machine?

 Album review: Hole's 'Nobody's Daughter'

Video: Scarlett Johansson at the 'Iron Man 2' premiere

Figure 2-16: Hierarchy in print media.

Was any design element colored or shaded in a unique fashion in comparison with other elements on the Web page? Was an image or illustration placed in a prominent place or scaled larger than others? Usually the answers to these questions and others like them will be yes. Was the use of scale, weight or color in the media that you've recently consumed haphazard or random? Or was it deliberate and intentional? In most cases, it's probably the latter. By emphasizing certain elements you can guide your users to make sense of the information presented and help them to consume the content in the desired order.

To look at this from the opposite angle, imagine looking at the front page of your favorite newspaper and seeing all the headlines at the same size and font weight. Would you be able to easily discern which story was the leading one for the day? Would you be able to scan the page and quickly determine a ranking of the available information that would help you make sense of the levels of importance of the content? Most likely, you would not. Content delivered without any evident visual hierarchy would quickly lose any coherent meaning. From a signal-to-noise vantage point, content that lacks hierarchical structure will

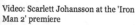

Content delivered without any evident visual hierarchy would quickly lose any coherent meaning. From a signal-to-noise vantage point, content that lacks hierarchical structure will largely be perceived as noise.

largely be perceived as noise. Clearly, as content producers we don't want this to happen!

Let's look at another example. The same visual hierarchy logic used to design traditional media artifacts such as newspapers, books, and magazines should also be applied to the design of interactive content. Figure 2-17 on the following page shows the home page of the *New York Times* Web site. Principles of visual hierarchy are present both in terms of the headlines (type size) and in the use and size of images on the page. It seems pretty obvious that the most important story is the one that concerns Goldman Sachs as indicated by the largest headline and the largest photograph on the page, both of which correspond to the article. Color is also used to emphasize headings in relation to body copy. Even physical location, obvious though it may sound, is clearly used to indicate importance. As you scan your eyes down the Web page you will see that

Figure 2-17: Successful use of hierarchy in online media.

items of higher importance are featured near the top of the page while those of lesser importance appear near the bottom.

Eye Movement/Tracking

Usability experts are professionals who study the most effective ways to design visual content. They are especially interested in studying how people use interactive mechanisms such as Web sites, hand-held devices, software applications and the like; pretty much anything with an interface that delivers information is of interest to them. One of the aspects they are keenly interested in studying is how people view and process information as it is presented to them. When people interact with digital content, they tend to exhibit similar behavior patterns. One method of studying how people use various types of media is by tracking eye movement across visual con-

Figure 2-18: Eye-tracking studies indicate that readers scan Web pages in an F-shaped pattern, as shown above.

tent. You can learn a lot about visual design best practices—what works, what doesn't and why—by studying the results of eye-tracking studies. Recent work in this area suggests many ways in which you, as a designer of visual content, can make the information that you present as interesting, salient and usable as possible. Having access to eye-tracking research can make a big difference in how you design visual content to have the greatest impact on your users.

So what exactly does an eye-tracking scan of how people look at displays of visual and textual information look like? When you scan a page of visual content you generally do so in F-shaped patterns. Your eyes first scan the information horizontally near the top of the page and then downward on the left-hand side. Next, you usually scan horizontally again near the middle (vertically) of the page, thus forming the basic shape of the letter "F." Of course, this doesn't mean that people don't look elsewhere on a page—they do!—but instead simply suggests where people are prone to look first and most often. If this knowledge were all that you could glean from eye-tracking studies, you'd still have a lot to work with. Knowing that users are keenly focused on the top and left-hand sides of something like a Web page suggests that key information like headlines, important images and/or navigation elements should be placed in these areas. Figure 2-18 shows the results of one study.

There's more though to what can be learned from eye-tracking research. Text and images that aren't accurate, precise or that are simply too small aren't often paid much attention by users. Larger images garner closer and longer-lasting views. The same is true with text. Headlines and sub-heads are essential, as users often first skim a page for interest before deciding where to spend more time. When it comes to body copy—the actual words that make up a story or article—users tend to spend more time with short, to-the-point paragraphs than they do with longer passages. In fact, recent studies suggest that people don't often read content word-for-word. Instead, one to two paragraphs are all that most readers pay attention to. Furthermore, superfluous information, whether text or images, is usually ignored; sometimes it even gets in the way, effectively creating informational obstacle courses for users.

Navigational elements, such as buttons and links, tend to work best for users when they are designed with a clear visual approach and are simple in their functionality. Additionally, a consistent approach to the design of all navigational structures on a Web site or page helps users to learn the information structure once and then

use it over and over again to achieve their goals. When the information presented is not novel or unique, text tends to work best; for users who have some amount of knowledge of the subject, text will suffice. However, when that information is unfamiliar or conceptual then multimedia elements, especially images, tend to work better.

OK, So Now What?

So now what do you do with your newly acquired knowledge of how the eye and the brain work together in an effort to make sense of the visual information that continually bombards you? How do you apply the preceding principles and theories toward your goal of becoming a savvy visual communicator? Like many intellectual activities, you first need to explore your domain and arrive at an appreciable level of understanding before you can begin to exploit that knowledge for a greater purpose, in this case crafting successful visual communication artifacts. To some extent, by reading through the introduction, you've already achieved some amount of understanding of your domain. What follows are some tips for transforming this new knowledge into useful design strategies.

> How do you apply the preceding principles and theories toward your goal of becoming a savvy visual communicator?

Figure-ground relationships: Unless you're striving to create a sense of ambiguity or confusion in your design work (sometimes that's the goal!), you should clearly define what represents figure and what represents ground in your visual designs. Doing so will focus the attention of your viewers and will allow you to successfully communicate the most essential aspects of any visual media artifact that you create.

Patterns: Given that your brain is constantly attempting to form patterns of meaning from the chaos of raw stimuli, designing visual media that incorporate intentional patterns will help your viewers to more quickly understand the intention of your design. You can take advantage of patterns by using design devices such as grids to help provide a logical and meaningful structure on which to hang the content that you want to communicate.

> By carefully delineating a visual hierarchy, you will allow consumers to best understand the information you've provided.

Gestalt: Strong visual compositions often take advantage of the princi-

ples of similarity and/or proximity. Clever arrangements of visual elements can be a sophisticated way to suggest subtext and imply meaning. Groupings of visual elements can create the illusion of form where there really is none through the manipulation of tone, color, shape, style and other physical attributes. The creative arrangement of text can also be used to suggest form that can work to complement or counter the actual meaning of the words themselves.

Eye tracking: As designers and communicators, you will be much better at your job if you understand as much as possible about where people look when they encounter visual content. Therefore, the whole point of understanding something about the study of eye tracking as it is applied to the consumption of visual media is simply to aid you in directing your viewers' attention to what you want them to see. Eye-tracking research shows us locations that people naturally look when they first encounter a layout of information. Placing important content in these locations is key if you want your designs to have the greatest amount of impact with the audience you're trying to reach.

Visual hierarchy: Remember, just because you can emphasize a certain visual element doesn't necessarily mean that you have to. You should take care to be deliberate about how you communicate the structure and order of the content that you create. By carefully delineating a visual hierarchy in your design work, you will allow consumers to best understand the information you've provided.

Being a savvy visual media producer in this day and age means having a grasp not only of content development skills but also a keen awareness of how that information will be delivered, who will be receiving it and how they are likely to use it.

Semiotics: In virtually all of the many types of media that you consume, you are inundated with signs and symbols, some of which convey their intended meaning effectively and some of which don't. As a digital content producer, you must be aware of how your designs function as semiotic devices. Making astute design choices about a particular photograph, logo design, illustration or even something as simple as a color or a typeface are all important decisions that you will have to make as you craft your content.

Conclusion

Visual communication isn't solely about look and feel, though paying attention to aesthetic principles is certainly important when you're trying to design visual media that make an impact. More cerebral issues of information design and usability are also important to consider when the information that you are delivering is complex—as it often is—and when the content will be consumed by large numbers of users—all unique individuals who possess varying amounts of technical and intellectual abilities. Being a savvy visual media producer in this day and age means having a grasp not only of content development skills but also a keen awareness of how that information will be delivered, who will be receiving it and how they are likely to use it.

Successfully addressing all of these issues requires that you have an understanding of the many ways in which the human mind works when it comes to synthesizing raw visual information into meaning. As a designer and developer of visual content, you should carefully consider the principles discussed in this chapter. While aesthetics will always be important, you should keep in mind that you aren't necessarily creating art but are instead designing visual communication that must, at a minimum, clearly communicate a message. In the world of visual communication, the successful delivery of information is paramount.

CHAPTER QUESTIONS

1. On a cloudy day, go outside, lie on your back and stare at the sky. What images do you see in the clouds? What gestalt principles define the ways in which your mind creates distinct images from the indistinct mass of clouds that you see with your eyes?

2. Think of the many strategies that you might employ in an effort to define a clear hierarchy of information in any form of visual communication. Pick a t site, a newspaper, a magazine—any form of communication that employs visual information—and evaluate the visual hierarchy that has been implemented.

3. Attempt to find an example of visual communication in which the visual information—images, illustrations, graphics, etc.—plays a more important role than textual elements in the effectiveness of the communication. Why do you think the visual

information is more effective at communicating the intended message? Bonus points if you can find an example that is entirely visual—no text—but still effective.

4. Consider all the semiotic devices—logos, symbols, icons, etc.—that you encounter on a daily basis. Which are the most effective? Why?

5. Can you find an effective example of figure-ground relationships used in visual communication similar to the Fed Ex logo?

3 A Brief History of Design

The digital and interactive media world uses elements of all media. Web pages contain video and audio; they are filled with still images and typography and artwork, and they often have components where the user selects what to see, hear, or read. Even though all of this is true, the basic container, or site, that holds the myriad of information for digital creations is still much more aligned with the print world than with any other media form. As a result, many of the elements that are a part of visual theory and design for the digital world are based in the world of print media. This chapter will provide you with a brief history of how design for the static images of the print world came about, realizing that the history of design for media continues to evolve and that basic digital design is but one more step in that evolutionary process. The chapter will also touch briefly on design elements that are noticeable in non-print media, too.

Media design for broad consumption by the public in the Western world did not start until Johann Gutenberg developed the printing press in 1455, but prior to that time, the idea that the most popular source of information—the book—should be visually appealing was widely accepted. In Europe, monks in scriptoria hand-copied texts, most of which were religiously based. The text was accompanied with ornate, colorful designs. There were no ideas of design principles, but there was a belief that intricately designed images on a page would enhance the text's contents. Even after Gutenberg introduced the printing press, the earliest of printed pages still contained ornate drawings to enhance and embellish the text. Visuals, however, had been a part of

KEY TERMS

banner headlines

Godey's Lady's Book

crawl

halftone process

headlines

JOIN, or DIE

modular design

multiple-camera setup

split-screen imaging

stereotyping

vertical design

woodcuts

the sharing of information for years; the printing press only made them much more accessible to people.

Woodcuts, images carved into blocks of wood that were then inked and printed onto leafs of paper, had been produced in Asia centuries before they appeared in Europe around 1400. The earliest woodcuts were relatively crude in the nature of the images, but this changed quickly. The use of woodcuts to enhance printed books was adopted in the last half of the fifteenth century. Rather than requiring that the illustrations on each page be individually drawn as was the case with hand-copied books and the Gutenberg Bible, the woodcut fit into the frame that held the lettering onto the press and could be copied with the text until the wood wore out.

Figure 3-1: Page from the Gutenberg Bible.

Because pictures can tell a story that all can understand—even those who are illiterate—broadside images became a common feature of books and of information dispersal from the late 1400s on. Highly ornate and detailed images of significant events throughout Europe—especially wars —appeared as single sheets that could be used to produce multiple copies for sale. Below the woodcut images, a caption explained the event and provided a date for the scene depicted.

Woodcuts would remain an important element of information dispersal in the United States from the introduction of newspapers, then magazines, into the twentieth century. Woodcuts in newspapers, though, were originally used for advertising. Printers enhanced the ads in their papers, which just as today provided the revenue to run the medium as opposed to subscriptions. Printers in the eighteenth century knew that an image would draw readers' attention, so they used little images of ships, horses, slaves, anything that might represent commonly advertised products, in the ad. It did not seem to matter that the same ship, for example, might appear in a dozen ads on the same page in a paper.

Creating woodcuts for news items, though, was generally not cost effective, and intricate woodcuts often took time. That meant that the woodcut image—if it was created for news—would need to be of something that could be used with an ongoing story where the timeliness of the image would not be critical. In addition, engravers were not commonplace in colonial America. Benjamin Franklin, however, did create several woodcuts to accompany articles.

Figure 3-2: Benjamin Franklin's JOIN, or DIE editorial cartoon, produced in 1754, demonstrated the power of visuals for persuasion.

In 1745, during the third declared war between the French and British that was fought in the American colonies King George's War, Franklin commissioned a woodcut of the attack plan on Louisbourg and Cape Breton Island in Canada. Less than a decade later in 1754, he produced the famous JOIN, or DIE editorial cartoon of the severed rattlesnake that represented the colonies as the fourth war between France and Britain in America was set to erupt. Both woodcuts were reused decades after their creation. The Louisbourg map appeared again in multiple newspapers in 1758, and the JOIN, or DIE woodcut was reused in 1765 during the Stamp Act crisis and as a symbol of revolt during the 1770s and during the American Revolution.

In the case of both woodcuts, the images were not created to enhance the design of the publication; they were created for informative or persuasive purposes. But, whether intended as design enhancements or not, woodcuts in newspapers created strong visuals that gave readers an understanding, or in the case of the severed snake a powerful emotional jolt, that would become a common occurrence in the nineteenth century.

Figure 3-3: James Gordon Bennett's coverage of the funeral procession of Andrew Jackson gave newspaper readers a page never before experienced.

On June 25, 1845, the eccentric and egotistical New York editor James Gordon Bennett gave readers something never before experienced in an American paper: a front page filled entirely with images. The occasion was the funeral procession for the nation's sixth president, Andrew Jackson. Six woodcuts filled the page with more on the inside of the *Herald*. Bennett had long used assorted woodcuts in his advertisements, expanding images from small, one-column images to multicolumn ones that represented a wide variety of products.

Images as a means to attract readership had already started a publication war in London between the *Weekly Chronicle* and the *Illustrated London News*, and the latter would become the inspiration for illustrated newspapers in the United States. The most famous were *Leslie's Illustrated Newspaper* and *Harper's Weekly*.

The illustrated newspapers filled their pages with woodcut engravings of almost any subject imaginable. They sent sketch artists on assignments. While on site, the sketch artists created rough drawings and sent them back to the papers' offices. There, other artists filled in all the details and readied the images for publication using the information sent from the field to accompany the sketches. Generally, the illustrated papers contained a double truck image at the paper's center. The center page was one large sheet of paper that made up two pages in the publication. The illustrations in the center could stretch across the center fold and provide a large and inviting image for viewers.

Figure 3-4: The illustrated newspapers of the mid-nineteenth century introduced visuals to the design of media. *Harper's Weekly* provided coverage of the shelling of Fort Sumter in Charleston, South Carolina, the opening salvos of the Civil War.

Illustrations were not the only design element that became a part of media in the nineteenth century. Headlines also played a critical role in the way publications were presented to the public. Short headlines began to be used on news stories in the eighteenth century. At first, they would only tell the origin of the in-

Figure 3-5: When President Abraham Lincoln was assassinated in April 1865, *The New York Times* used a series of seven decks in different sizes and fonts, each revealing another detail of the shooting.

formation. For example, a Boston newspaper might have headlines that said "London," "Philadelphia," and "New York" so that readers would know where the information was obtained or that the location was the subject of the news. During the French and Indian War, headlines began to contain a little more information, but this use of headlines didn't last. In the nineteenth century from the penny press period on, though, headlines began to assume a greater role in the way newspapers were presented. Editors still generally thought of the information in their papers as being complete in one column before moving to the next, which meant a person would read all the information in the first column of a paper because the story continued in that column until it finished. Another story then started, and if it wasn't finished continued to the top of the second column.

Headlines, then, introduced each story. The important ones had a main headline followed by a series of subheads, each usually in a smaller font size or even a different font. These decks could continue for any number of levels. Consider the example of headlines that *The New York Times* ran on its story of the assassination of Abraham Lincoln on April 15, 1865. The *Times* used a series of seven decks in different sizes and fonts. Each revealed another detail of the shooting but also added visual elements to the design of the page. The *Times'* front page also showed how the story in the first column con-

tinued into the second and third column of the front page. Readers simply knew to continue to the top of the next column if they wanted to complete the story.

The report of Lincoln's assassination included another design element—the black border. Since the 1700s, printers had used black border to symbolize mourning. The gutters between the columns were filled with black to show tragedy. That was the case here.

Figure 3-6: William Randolph Hearst's *New York Journal* used multiple-column headlines and elaborate illustrations in its coverage of the Spanish-American War.

Illustrations and large, bold headlines that stretched across multiple columns were the trademarks of the most powerful American media in the 1880s, 1890s, and into the twentieth century. Stretching headlines across multiple columns was known as stereotyping, and printers developed the practice early in the nineteenth century. But, the high-speed Hoe rotary press, which could print up to 20,000 pages per hour, was designed to print text in one-column format only.[1] For that reason, most newspapers continued to print in that manner rather than experimenting with new designs in layout.

The idea behind multiple-column headlines and the use of illustrations was to draw in as many readers as possible to the sensational news reports that filled many of the papers of the era and earned the leading proponents of this style of journalism—Joseph Pulitzer and William Randolph Hearst—the moniker "yellow journalists." Newspapers created elaborate illustrations, and the largest papers began to incorporate photographs into designs. Photographs had been around since the 1830s, but not until the 1880 development of the halftone process, which turned images into a series of dots, was it possible to run photos in newspapers.

The results of the changes in design elements catapulted newspapers to new numbers in circulation and in the total number of

1. Sally I. Morano, "Newspaper Design," in Wm. David Sloan and Lisa Mullikin Parcell, eds. *American Journalism: History, Principles, Practices* (Jefferson, N.C.: McFarland, 2002), 319.

newspapers that served the nation. In 1898, when the U.S.S. *Maine* exploded in Havana harbor, Hearst's newspaper used multiple design elements to draw readers, including large headlines, boxed items, and visuals.

The yellow journals also added another new dimension to design: color. Pulitzer introduced color comics with the *New York World* in 1889, but the colorful images weren't a regular in the paper until 1895. Color was not something that most newspapers were able to provide because of cost, but color had long been a part of the design features in magazines. *Godey's Lady's Book*, the most popular magazine for much of the nineteenth century, knew the value of color. Many of its fashion plates of dress designs for women were hand tinted by hundreds of women across the country. Media professionals knew the value of color in design but had to wait for affordable technology to make it more feasible to create designs to attract the audience.

Newspapers continued to provide interesting design concepts with visuals in the early years of the twentieth century. Photographs, which had rarely been used, suddenly became a regular feature of many of the larger publications. Photographs presented in shapes and at angles were one way that editors changed and enhanced publication appearance. While competition had always existed to some extent among papers, Pulitzer and Hearst lifted one-upmanship to new levels as they battled with content and also with design. During the Spanish-American War, banner headlines above their papers' nameplates voiced all sorts of declarations, claims, and questions. Not completely new—the *Maryland Gazette* used them during the French and Indian War—the way that Hearst and Pulitzer used them created a sense of urgency in terminology and in the size of the type.

Banner headlines would become one of the major design components in the twentieth century along with the move to tabloid-sized journals in what would be called the Jazz Age. Even bolder head-

Figure 3-7: The *New York Daily News'* dramatic coverage of the execution of Ruth Snyder shows how design accentuated the sensational nature of 1920s tabloids.

lines than those used by the yellow press were a hallmark of design in tabloids along with large illustrations. Design components often accentuated the sensational nature of the tabloids, and none better illustrate this than the *New York Daily News'* dramatic coverage of the execution of Ruth Snyder for the murder of her husband, Albert. As photographs became easier and cheaper to print, newspapers and magazines increasingly used them to draw in readers, enhance stories, and create more elaborate designs. Guglielmo Marconi's success in sending wireless messages from Britain to North America was of such significance that it spurred massive media coverage throughout America and Europe. Photos of the inventor, the elements of wireless—anything that was associated with the new medium—found its way into publications, the more images available, the better. The same held true with the move toward women's suffrage. Perhaps for the first time, images of women, in elaborate newspaper layouts, were presented to the public.

Figure 3-8: In the mid-1970s, *The New York Times* pioneered the practice of themed section fronts, giving designers more opportunities for visual storytelling.

Despite the ability to create elaborate layouts, most newspapers through the 1950s and into the 1960s opted to present information more in the style of earlier newspapers. While headlines were often larger and could stretch across multiple columns, editors preferred a more vertical style of news presentation, much like the *New York Times* and *Wall Street Journal* front-page layouts that lasted into the twenty-first century. Generally, the way pages were organized depended more on custom—why the *Times'* and the *Journal's* layout style persisted for so long—and because it was easier for typesetters to create the narrow, vertical files.

Design of newspapers became a more specialized task in the 1970s, with designers and graphic artists slowly gaining more input into daily decision making. In the mid-1970s, *The New York Times* pioneered the now-standard practice of themed sections within each day's paper, with section fronts such as Arts and Food beginning to more resemble magazine covers

than traditional news fronts. Influenced by the changes in the *Times* and informed by new professional organizations such as the Society for Newspaper Design (later changed to the Society for News Design), newspapers around the country began to use larger headlines and images, with photography taking a more prominent role.

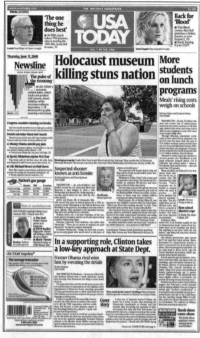

Around the same time, modular design became the dominant layout style. In modular design, headlines, stories, images, and cutlines are laid out on a page so that they create a rectangle. Layouts done in this way make it easy to move elements to different places on a page. Modular design also allows editors to remove a story element from a page and replace it with another that fits into the same space. Doing this was almost impossible with vertical and horizontal page layout because of the odd shapes that stories and artwork often assumed. *USA Today* perhaps offers the most influential example of modular layout, which lets you know that this design

Figure 3-9: The era of modular design was exemplified by the huge popularlty of *USA Today*.

style has only been around since the early 1980s. With *USA Today*, a fixed set of boxes exist on the front page. Stories, headlines, and artwork can simply be plugged into the space. What made *USA Today* unique was the fact that the modular design of the front page rarely changed, and if it did, the changes were only minor. Now, modular design with newspapers is almost universally accepted as the best means of presenting information to readers.

Design in Broadcast

Because television is a medium of movement, it does not have a history of design like that of print. This does not mean that design elements are not employed in the creation of programming. Elements of design for television and other media of moving images will be discussed at length in the Principles of Design and Composition for Video chapters. There have been some elements of design that have changed the way television, particularly TV news, looks, though.

First, because movement is what made television the medium that captured the nation in the 1950s, early newscasters had to do more than read the news. They added movement, even though they might do nothing other than stand up from a seat behind a desk and move to the front of the desk and stand there or sit on the desk.

Most Americans remember the crawl at the bottom of the screen that provided all sorts of information as Americans watched in awe the images on the screen on September 11, 2001. Most attribute the crawl to CNN when it joined the broadcasting world in the 1980s. The crawl at the bottom of the screen, with additional information that did not correspond with what was happening in the main frame of the picture, actually was introduced in 1952 when NBC first aired *The Today Show*. As host Dave Garroway wandered around the set talking to the audience while showing them images, people at work on the set, and then doing interviews, other information moved across the bottom of the page.

Later, networks added split-screen imaging. By the time we reached the twenty-first century, viewers were being provided with multiple images along with even more information streaming across the bottom of the page. The move to the 24/7 news cycle required the introduction of numerous graphics and even more images to make what was happening on screen even more visually appealing to audiences. Networks began to create visuals for any event that might require recurring reports.

Figure 3-10: Graphics have become a staple of election coverage on television.

Presidential elections are an excellent example of this kind of design visual that is found in broadcast. NBC's "Decision 08" image appeared at the beginning of each segment of its coverage on election day. Network affiliates co-opted the design and added information about the local station, generally below the Super Tuesday banner.

But, the use of logos or visual design elements in broadcast has existed since television exploded into the American consciousness at the beginning of the 1950s. CBS, for example, began to use its "eye" in 1951, and as the network's trademark, it became synonymous with the Columbia Broadcasting System. Since its introduction, the eye has appeared in color, without a background, and teamed with all elements of CBS programming, but it has not changed its basic design. It is integral

to all CBS offerings, including its Web site. Here are examples of the logo from its first incarnation in 1951 through its use on CBS.com.

In terms of TV entertainment and news, programs were initially produced with a single camera so that the audience watched in much the way it would have if people were attending a live performance like a play or a musical production. But, cinema had long gone to multiple cameras to film, and television as it matured copied motion pictures. As programming became more important and involved, those producing it began to experiment. One of those experiments involved the use of multiple cameras to shoot programming, especially the popular situation comedy shows. Many of the early programs on television were filmed in front of live audiences, a holdover from radio entertainment. Several TV programs early in the 1950s tried using multiple cameras, but Desi Arnaz, who with his wife Lucille Ball created one of the most successful sitcoms of all time, *I Love Lucy*, standardized the multi-camera setup for sitcoms and many other programs that needed to film in front of a live audience. Arnaz set up a trio of cameras to capture the action on a set. Now, when shows were presented, viewers could experience the action from multiple angles. The innovation became a staple of entertainment production, especially in situation comedies. Some programs added a fourth camera for an even more varied presentation.

Figure 3-11: The original 1951 CBS logo (top) had clouds behind it and evolved into the iconic CBS News logo (middle). The "eye" image has evolved into the digital age with its current use on CBS.com (bottom).

Moving Online

When Web sites were introduced in the early 1990s, the idea was to create a means of linking basic information so that it could be shared and used by anyone with access to it. Designers saw the Web's potential for providing sounds, images and video in addition to text but struggled in its early years to provide a true multimedia experience, or sometimes even to get text-driven pages to appear correctly on both PCs and Macs, across multiple browsers (Netscape and Microsoft's Internet Explorer, primarily) or that loaded in a reasonable amount of time, since user connections were generally on

slow, telephone dial-up modems. As connection speeds increased, compression standards such as MPEG made audio and video files much smaller in size and easier to deliver so that by the early part of the new century, multimedia were more seamlessly integrated. The widespread adoption of Cascading Style Sheets (CSS) and the evolution of the HTML standard gave designers greater control over how the finished product would look.

In 2010, the new HTML5 protocol promised to integrate video into Web sites without the need for add-ons such as Adobe's Flash. Though designs were and in some cases continue to be ungrounded in sound design principles, many sites combine stunning graphics with text, sounds, and moving images that allow users to interact on multiple levels.

The best of sites are designed to lead users through them. Many online designers have realized that Internet users want sites that allow them to move through them without thinking about what to look at next on the site. Some of the latest online design studies have suggested that this design pattern creates an "F" shape.[2] Readers scan the page horizontally before looking vertically. In general, viewers tend to scan text on the page while paying more attention to images. This study confirms what creators of media pages have believed since the time of Gutenberg: People are drawn to images be they ornate, colorful designs; images or photographs; or video. That is where adopting good design practices become essential.

CHAPTER QUESTIONS

1. Why were woodcuts added to early designs?

2. How did print design change with the introduction of publications like *USA Today*?

3. What improvements in design accompanied the design changes of the 1970s and 1980s?

4. How did the crawl and the split screen enhance the visual design of television?

5. How do you think that the elements of design that developed with print and then with television affect online?

2. Jakob Nielson and Kara Pernice, *Eyetracking Web Usability* (Berkeley, Calif.: New Riders Press, 2009).

4 Ethics: What You Can and Cannot Do

A documentary filmmaker follows teenagers during their senior year of high school. The camera crew is present for discussions of teenage sex, underage drinking, prank phone calls, and acts of vandalism. What ethical issues arise as a result of taping this information? What about putting it into the film? If we assume that the teens and their guardians have signed releases to be in the film and that all the information portrayed is true, we essentially remove any privacy or defamation legal actions. But what ethical issues arise as a result of taping and then showing these scenes?

The documentary filmmaker is legally able to shoot the footage of these teenagers, edit it into the film and show it in theaters. The question is not can he or she do it, but rather should they. The law tells us what we can do, but ethics tells us what we should do. Although ethics and morals are often used interchangeably, ethics focuses on rational ways of deciding what is good for individuals and society. Morals might be based on individual values, but ethics should be explainable and justifiable even to those who do not share your values. The hard part is that ethics often involves making decisions among competing moral principles.

Ethical decision making has garnered substantial intellectual attention historically and contemporarily. From the philosophical approaches of Aristotle's Golden Mean, Kant's Categorical Imperative, Mill's Principle of Utility to modern philosophers John Rawls' veil of ignorance and Anthony Weston's ethical toolbox, many thinkers have grappled with ways to think about complex situations.

Greek philosopher Aristostle was a student of Plato and lived more than 2,300 years ago. Aristotle's Golden

KEY TERMS

Aristotle's Golden Mean

Kant's Categorial Imperative

Potter Box

Principle of Utility

Mean stated that ethical behavior comes from hitting that just-right point between two extremes. He emphasized ethics focused on individuals who know what they are doing and act with good moral reason and character. This should not be read too simplistically as a compromise. The key is to find the virtuous choice in the balance between two things that are important, sensitivity for victims and their families and the need to report the awful truth about a crime, for example.

Others suggested that ethics lies in the act rather than the actor. Eighteenth-century German philosopher Immanuel Kant explained ethical behavior with the categorical imperative, which asked people to consider what would happen if everyone acted in the way that we are considering. He argued the unethical choices cannot be justified by positive outcomes or that the ends cannot justify the means.

A century later, John Stuart Mill wrote of the principle of utility, which argues for the greatest good for the greatest number. Another way of thinking about this involves considering that which causes the least pain as the best choice.

Today, philosophers continue to ask questions about how we can behave ethically in the world. John Rawls suggests a veil of ignorance where we make decisions without considering our own bias, prejudices or status, or the status of the other people involved. This way we would make decisions based on fair principles because without knowledge of your own status or others', you would not be able to tell if you would suffer or benefit from a biased system. How would this apply in a media situation in your chosen area of interest?

> John Rawls suggests a veil of ignorance where we make decisions without considering our own bias, prejudices or status, or the status of the other people involved.

Anthony Weston created a toolbox for students of any discipline to work through ethical issues in a clear and systematic manner, paying careful attention to the values at stake on all sides of an issue and looking for creative solutions to age-old difficult problems.

Other decision-making models such as the Potter Box (Christians, Fackler, & Rotzoll, 1995), Sissela Bok's model for ethical decisions (Patterson & Wilkins, 1994 and Bok, 1989), the Poynter Institute checklist of questions to make good ethical decisions (Black & Bryant, 1995) offer students a great starting point for thinking ethically. For example, Bok suggests that when faced with an ethical dilemma one should consult your conscience, consider alternatives, and take the point of view of all involved into consideration

(Bok, 1978). The so-called Potter Box relies on four dimensions of moral analysis: Facts, Values, Principles, and Loyalties. The person making the decision must state all facts without making judgments. State and compare the merits of different values you stand for such as honesty and responsibility. When you ultimately reach a conclusion, your decision should not go against these values. For example, one shouldn't decide to do something dishonest if that person sees honesty to be very important. The decision maker will also employ principles or modes of ethical reasoning from other philosopher's work, such as Aristotle or Confucius. One must also address allegiances or loyalties such as to the audience, employer, industry co-workers or stockholders. The four dimensions are linked so the analysis need not proceed in any particular order (Fitzpatrick and Gauthier, 2001).

> The so-called Potter Box relies on four dimensions of moral analysis: Facts, Values, Principles, and Loyalties.

Applying Ethical Principles to Your Digital Projects

It is fairly easy to shoot video, capture audio and stills, and put them on the Web (although as other chapters attest, these tasks require significant thought in terms of design and aesthetics). With great power comes great responsibility. The rest of this chapter will help students make difficult ethical decisions in multimedia production. Students will think about the people featured in their content creations, learn what is appropriate when capturing and then manipulating images, and consider how sound and images of people and events can misrepresent those people and events.

Capturing Your Media Material

When we work with people to tell their stories, market their product, or promote their organization, we face a host of ethical issues in how we represent people, events, and products. These issues arise when capturing video, audio, and still images or collecting information. At times our subjects will tell us things that we will choose not to include in our work. Let's go back to the example of the high school students and the documentary filmmaker. Filmmakers often have information that they choose not to include because of the harm that would come to the subjects of their work. Teenagers and even their guardians who agree to be part of a film may not fully re-

ANTHONY WESTON
MAXIMS FOR THE MEDIA PROFESSIONAL

Dr. Anthony Weston is the author of numerous books on ethics, including *A 21st Century Ethical Toolbox* (Oxford University Press, 2007).

Ethics offers us a set of *skills*—skills for living mindfully and well; skills for carrying on in a considerate and honorable way with others; skills for making an intelligent and constructive difference in problematic situations.

Typical views of ethics put more emphasis on rules, and/or on ethics as a mode of arguing about hard choices or "dilemmas." Looked at in those ways, ethics is limited and probably not a very appealing subject, like doctor visits for illnesses you'd rather not have. Think of ethics as a set of skills, though, and rules and controversies and "dilemmas" are not necessarily the main events—they are only the legalistic or moralistic side of ethics. Ethics in a broader sense is about appreciating the whole range of moral values and how they interweave, support, and challenge each other; about a variety of ways to approach conflicts and reach agreements, such as balancing and integrating values; about moral vision—looking beyond controversies or dilemmas to bigger hopes and shareable ideals; and, in the end, about effective and constructive joint action as well. Ethics has many sides!

Here are a few ethical maxims from a broad and practical point of view, with special attention to the media professions.

Use your wide-angled lens Moral values are those values that concern the basic needs and legitimate expectations of others as well as ourselves. This is a broad category. Expect to recognize *many*!

Journalism is a profession dedicated to helping us to know the world, and especially to know enough of what is happening in our common life to be able to take a constructive part in it. At the same time, reporting takes place within a larger social context—it is, after all, a mode of relationship between people—so many other values also come into play, often restricting or redirecting its purely information-gathering function. Our job is to respond to all of these values, as far and as best we can, even when they conflict. Sometimes all we can do is find a decent *balance* between them—and there's nothing wrong with that!

The Golden Rule The Golden Rule asks us to take others' needs and expectations as seriously as we take our own, by the simple method of putting ourselves imaginatively in others' place. If you are a videographer or reporter wanting to be sure you are treating your subjects with respect, for example, ask yourself how *you* would want to be portrayed if *you* were the subject—if you were the one in the picture and not the one behind the lens. Literally putting yourself into the situation (and note: *not* "putting the camera down" but putting yourself on the other side of it) can help you see it more clearly, and know better how to respond.

Use your investigative skills Reporters learn to look at many sides of an issue, to find perceptive and varied sources, and to look behind what's "obvious" to see a more complex picture. All of these skills apply in ethics as well. An ethical issue is not just a puzzle to solve—it's an interesting situation to *look into*. You might ask why a certain ethical issue comes up in the form or at the time it does. Manipulative or exploitative advertising to young children, say: it's not just a question of what you yourself should do, if you are an ad-maker, but also a larger social question, such as why we allow the advertising of *anything* to young children, or even why we allow TV to be so many young children's main source of experience of the world.

You know the importance of seeking multiple sources, not just one. Extend that understanding to ethics too. Talk to other people about ethics and media. Talk to other media professionals. Talk to people entirely outside the field. Talk to your parents or kids and friends. You *and* they will learn a lot!

Be proactive Don't wait for ethical "dilemmas" to arise and only then try to deal with them. Instead, try to arrange your work so that it creates fewer ethical binds in the first place. Rather than worrying about how far to go in making ads for young children, for example, you might specialize in ads for adults. Or join an ad firm whose selling-point is precisely their ethics—they may not even take such accounts.

An example in the text is a documentary filmmaker concerned with her subjects' embarrassing or harmful self-revelations. You could prevent at least some of these quandaries by periodically reminding your subjects that they are after all being filmed. Let *them*, in effect, edit (or revise, or even maybe improve) what they are saying and doing as they are saying or doing it. *Don't assume that you are the only one who cares.* A friend of mine gives ethics talks at local businesses. He reports that after every talk countless employees come up to him to thank him and say things like "I wish other people at my firm felt the same way." My friend just points to all of the other people in line and says: they *do.* Each of you is assuming that you are the only one—but you're not! It only takes someone like you to step forward first, and others will be right there with you. (Besides, if sometimes you really *are* the only one with ethical concerns, you also have something very special to offer your fellow professionals and firm.)

Go beyond the bar The law poses an all-or-nothing bar: once you're over it, you're legal. In ethics, though, you can and should always ask how you, and we, can do *better*. Are there creative or unexpected ways to change or re-approach the whole issue? Sure, bemoan how gullible so many viewers seem to be; better, try to avoid manipulating people yourself; but how about actually helping people to be more critical viewers, say by promoting critical literacy in your own media productions? Sure, worry about stereotyping (ethnicities, political activists...) in the media; better, try to avoid stereotypes in your own work; but what about deliberately *counter*-stereotyping in your work? There's always a next step!

alize the impact that this participation will have on their lives. A teenager who brags about bullying other kids or makes racist comments will perhaps later mature and be mortified by her characterization in the film. What obligations do we owe the subjects of our work?

The Society of Professional Journalists states that "Ethical journalists treat sources, subjects, and colleagues as human beings deserving of respect." The code goes on to outline that journalists should "show compassion for those who may be affected adversely by news coverage. Use special sensitivity when dealing with children and inexperienced sources or subjects."

Documentary filmmakers Steve Bognar and Julia Reichert faced several challenges when they worked on their film *A Lion in the House*, which is about children with cancer. They were present with cameras for vulnerable moments with sick kids and scared families. Bognar said, "There are moments when something is happening in the room and you want to put down your camera and just be a human being." Reichert said that they had to force themselves to keep shooting, knowing that the images would be a powerful way to convey the impact of childhood illness. But they often edited the footage in ways to give as much dignity to their subjects as possible without taking away from what really happened in the scene. Bognar gave one example when one of the main subjects in the film threw up during a treatment. The teenager was sitting with vomit all over his chest for a long time. They edited the scene to be brief because it seemed like the right thing to do for a subject.

Marshall Curry said, "It is so important that you earn the trust of the people who you feature in your films so that you can allow them to reveal themselves to you. I take that trust seriously and understand that I must show people fairly and respectfully. That doesn't mean hiding conflicts or negative issues, but it means showing those things with context and humanity and sense of humor—because we all have negatives. I think that's a big part of what ultimately connects audiences with characters in a film."

As you start to work with people and tell their stories through your media projects, you'll want to think carefully about how you portray your participants.

> " It is so important that you earn the trust of the people who you feature in your films so that you can allow them to reveal themselves to you. I take that trust seriously and understand that I must show people fairly and respectfully. That doesn't mean hiding conflicts or negative issues, but it means showing those things with context and humanity and sense of humor— because we all have negatives. "
>
> **MARSHALL CURRY**
> DOCUMENTARY FILMMAKER

Specifics About Capturing Images

Several ethical dilemmas arise when talking about visual images. Visual bias in the media occurs in two forms: manipulation before capturing the image—through camera angles, lighting, and placement of the subject—and manipulation after capturing the image—through digital manipulation, cropping, or changing the speed of the video.

The more subtle manipulation occurs before the image is taken when choices such as camera angle and lighting can add a subjective tone. These are often not even thought of as manipulation, but they can have an effect on the way the viewer sees the subject. These techniques can make anyone look good or bad. A 1947 *Life* magazine photo spread illustrates this point. The magazine ran a series of photos challenging readers to distinguish the mystery writers from the criminals as a way of disproving the theory that some people have criminal faces. Although all the photos were shot using the same focal length, the mystery writers who were intended to be mistaken as criminals were photographed in poor lighting from unflattering angles.

> Several ethical dilemmas arise when talking about visual images. Visual bias in the media occurs in two forms: manipulation before capturing the image and manipulation after capturing the image.

Jill Greenberg is a photographer famous for a series of photos of bawling toddlers. She achieved these shots by giving the children a lollipop, then snatching it away and snapping a photo of the reaction. During the 2008 presidential election, Greenberg was commissioned by *Atlantic* magazine to take a cover photo of John McCain. After snapping several shots for the cover, Greenberg moved McCain to another set up with a strobe light and what appeared to be a more flattering light set up that was not actually on. The effect was a garish and unflattering photo with horror movie shadows across McCain's face and on the wall behind him. Greenberg posted this photo on her Web site and later discussed in an interview how easy it was to trick McCain into the photo.

Bob Garfield of WNYC's *On the Media* interviewed Greenberg and other photographers about ethics. Garfield stated, "In photography, this reality thing is hard to pin down. Each of a sitting's dozens or hundreds of shots is a frozen two-dimensional representation of a living, moving, three-dimensional being, a laser-sliced instant invisible in real time. It may be a reasonable likeness, it may express

some aspect of mood or personality, but it is, by definition, out of context." Garfield went on to state, "In purely artistic terms, such sentiments are unassailable, but if a magazine writer marched into a profile interview with the announced intention of cajoling from a subject a single word or phrase that would be the sole focus of the profile, well, that's pretty much the definition of 'gotcha' journalism. Is creating a disturbance ever a reasonable journalistic technique?"

One photographer admitted that he is surprised that he is allowed to get away with the things he does. When asked about ethics, Greenberg stated, "I went to art school, so I don't know what those canons and ethics are." So what do you think? If you are shooting portraits for the cover of a newsmagazine, what obligations do you have to your subject's vanity or good image? If you are illustrating, as

GEORGE PADGETT
WHY DIVERSITY IS IMPORTANT

George E. Padgett is the author of *New Directions in Diversity*, Marion Street Press, 2006, and *Diversity A to Z*, Marion Street Press, 2011.

Diversity is more than a popular buzzword bantered about in marketing and college admissions circles. And it is about more than race and ethnicity! In addition to those generally perceived flagship terms, diversity encompasses gender, economic class, sexual orientation, national and geographic origin, age, spirituality, physical and mental ability, and even political affiliation. Sometimes described simply as difference or otherness, it requires more than the mere presence of variance in skin color or socioeconomic condition. To have real meaning, the goal of inclusion must also be a part of the diversity formula. Not just tolerance. Not just acceptance. People who are different must be brought into the inner circle, consulted, respected and ultimately celebrated as equals.

In mass communications or media-related professions, diversity usually relates to two distinct areas: (1) the diversity of administrative and employee pools; and (2) the diversity of content or degree of coverage of various underrepresented populations. The failure of American media regarding the first consideration is easily quantified by a simple comparison. While the population of people of color (Black, Asian, Hispanic and Native American) in the U.S. currently stands at approximately 34 percent, the percentage of the same population groups represented in the composite American newsroom equals only 13.25 percent. That's a huge difference! Success on the second dimension also is easily discounted. Consider this: there are more than 1.5 million non-institutionalized wheelchair users in the United States. One in 200 people use wheelchairs as their principal means of mobility. Then ask yourself, when was the

one magazine was, fears that the public might have about Michelle Obama, can you take from the hundreds of smiling photos that you took, the one that shows her staring straight into the camera with arms crossed and put that in the magazine?

We know that lighting and angles in still images do affect perceptions of the subjects in them. An established body of literature has documented visual bias from the way television images are constructed as well. Scholars have used content analysis to show that camera angles and focal lengths used with moving images can have a biasing effect. Kepplinger (1982) asked photojournalists what techniques they used to put a person in a negative light. He then looked for such practices in election coverage to show how the "optical commentary" biased the coverage. Grabe (1996) also found visu-

last time you saw someone in a wheelchair featured in a newspaper article, in a local news broadcast, on a television series, in an advertisement in any medium, or in a popular movie?

It also is important to acknowledge the existence of diversity within diversity. White Americans for generations treated people of color as though they were homogeneous groups. African Americans were African American, Asians were Asian, etc. Of course, we recognize today that such is not the case. A Midwestern daily newspaper publisher, for example, seeking to create diversity among her employee pool would not hire only black journalists who had grown up in largely white middle class communities, attended private schools and graduated with journalism degrees from Northwestern University. All Asians are not Chinese or Korean; all Hispanics are not Mexican; and American Indians or Native Americans are people of distinctly different tribes from Cherokee to Lakota to Pueblo. In fact the Bureau of Indian Affairs currently recognizes 564 separate tribes in the United States.

Diversity and inclusion are important for a number of excellent reasons. In terms of ethics and social responsibility, it is clearly the right thing to do. As applied to the practice of diversity in journalism, for example, reporters should use diverse sources, cover the undercovered, and avoid stereotyping and profiling. The practice of diversity is simply good journalism: fairness and accuracy and covering the total community without bias. Finally, diversity is important because it is good business. With an increasingly diverse society, it only makes economic sense to appeal to as broad an audience as possible.

Regardless of the medium, the ultimate goal of creating a society that sees beyond difference and recognizes the unique characteristics of individuals as strengths rather than limitations depends on how they are integrated into and portrayed by the evolving mass media of the 21st Century. Diversity is both that simple, and that unbelievably complex.

al bias in South African election coverage. Tiemens (1970) used experimental design to show how camera angles affected the credibility of people featured in the news. Other experimental studies have shown that these biased camera angles can create negative impressions of the people featured and that viewers use these impressions to unconsciously judge the people in the news (Mandell & Shaw, 1973).

So far we've talked about how images are chosen and framed when taking still photos or video. Far more blatant and conscious is manipulation after the image is captured. Generally, digital imaging technology is used to correct mistakes such as poor lighting or to restore old photographs by removing scratches or enhancing faded negatives. Sometimes, however, more dramatic changes are made such as removing an object that is visually unattractive or distracting, such as a soda can or light pole. Other times the image is digitally enhanced to change the appearance of the main subject. Well-publicized examples include whitening and straightening the teeth of septuplet mom Bobbi McCaughey for a *Newsweek* cover photograph or darkening a photograph of O. J. Simpson on the cover of *Time* magazine. An example of digital manipulation from televi-

ELLEN WEAVER HARTMAN
A VIEW FROM THE PROFESSION

Ellen Weaver Hartman, APR, a Fellow of PRSA, is President/Atlanta Office of Weber Shandwick

Truth and transparency remain the cornerstones for the PR professionals. I adhere by the PRSA code of ethics and require my team to do the same. At Weber Shandwick, we also have to take a required annual course on ethics. This keeps us abreast of situations that may arise in doing business and strategies for managing them well. As a global company, Weber Shandwick insists that its employees understand local customs and how to effectively remain true to our company's and PRSA guidelines.

Being an agency with 130 offices around the world, Weber Shandwick is constantly having to deal with conflict in client in situations. Some clients are global and are serviced by many offices. Other clients are just managed through one office. Although it is a difficult conversation, we make it a policy to first ask permission from our existing account before allowing another office to pitch a competing brand. Many times, clients see conflict situations differently. KFC allowed us to pitch and win Carl's Jr. brand, for example. It's always good to ask first as it strengthens the relationship and the trust with our clients.

sion news is placing the CBS symbol over an NBC advertisement in Times Square during New Year's coverage. Digital liposuction happens routinely for celebrities who appear on magazine covers. The *New Yorker* profiled Pascal Dangin, who runs a studio in New York and is credited with a serious understanding of anatomy and ways to make people who already look really good, look even better, earning him the nickname "the photo whisperer."

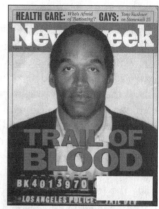

These are areas for discussion and debate, and you'll talk more about them in an ethics course. For now, the idea is to think about ways that you are manipulating the image. Also, think about how your chosen profession and the viewers of your work would respond to such manipulation.

For example, surveys of photo editors revealed that they were critical of digital alteration of photos beyond standard cropping or lightening (Reaves, 1993). Empirical studies have also documented how viewers perceive manipulation of images (Huang, 2001). One of the subjects in Huang's study (2001) said of the O. J. Simpson manipulated photo, "They wanted him to look dark and like a criminal (before) the court even tried him" (Huang, 2001, p. 162). Studies have also documented how slowing videotape speed can create negative impressions about the people shown (Barnett & Grabe, 2000).

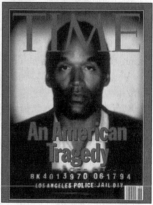

This potential for bias from visual images must be considered when taking and editing photographs or video.

Figure 4-1: Photo manipulation might go unnoticed unless the original photo is also available as was the case with the mug shot of O.J. Simpson used as is for *Newsweek* and darkened for *Time*.

Publication of Sensitive Material

With the Internet, it is much easier to mock videos or photos of real people. One blog post that went viral through reposts on social media sites and other blogs featured Olan Mills photos. The comments mostly made fun of the outdated fashion or hair, funny backdrops, or expressions.

Some of the photos on this site have pretty hurtful comments about the real people featured in the photos. How would you feel if this site featured a photo of your now-deceased grandparents and

THE ETHICS OF CROPPING

In common language we say that people "take" photographs. This suggests that there is little creativity involved. The photographer is simply taking what is there. It would be more accurate (though more awkward) to say that we "make" photographs. This would account for the fact that really we are creating a visual scene with the choices we make in framing or cropping the photograph. This is important to consider for ethical reasons.

Close up shots are almost always more interesting to the viewer. But keep in mind—especially with photojournalism—that tight frames can remove part of the story. Think of a photo in a newspaper of a protest on campus surrounding the food in the dining halls. If you frame a nice tight shot of four people screaming and holding signs, it might send the message that lots of students

> The way you crop a photo will determine how it is perceived. The viewer often needs the surrounding cues to get the correct idea of the situation.

are riled up about this issue. But if you show a slightly wider shot, you might see that these students are the only four students protesting and that all around them are students happily eating in the dining halls who seem to be oblivious to this issue.

This is also an issue with cropping. The way you crop a photo will determine how it is perceived. The viewer often needs the surrounding contextual cues to get the correct idea of the situation.

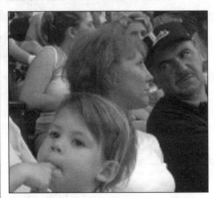

Figure 4-2

Figure 4-3

Take a look at this photo. Perhaps it looks as if this couple is annoyed with the child or discussing her behavior. Maybe she is ignoring them.

Now look at the same photo cropped on the other side. A look at the entire photograph without cropping might tell both stories.

Another ethical concern comes in the way we juxtapose images in layout and video editing. This can create a reality far different from what actually took place. For example, here is a photo of a little girl in the snow. You might see this photo and think that she is cold (which is actually the case).

Figure 4-4

But put this photo next to this one and a very different impression emerges.

Figure 4-5

These photos were taken at different times. The man is not throwing the snowball at her. But the layout above gives that impression.

The way we "make" the photograph needs to be true to what actually happened. Photographs and video can make things appear very different than the truth. Some would argue that the "truth" will vary from person to person and objective truth may not be obtainable. But it is important to strive toward objectivity. You want to be diligent to not consciously violate what you know to be true.

When you take photos, you are creating an impression, dictating the reality for those who were not there. It is important to make sure that the reality you portray is fair and accurate.

made fun of the way they looked or made comments about how many kids they had? There is no clear legal remedy for use of these photos on a humor site if the site did in fact have the rights to the photo and was not using photographs of people without consent to sell a product. But should there perhaps be nonlegal ways to voluntarily curb hurtful things on the Internet?

The issue of the *Star Wars* kid provides an interesting case test. The *Star Wars* kid was a teenager in Canada who filmed himself with a golf ball retriever pretending he was fighting in a *Star Wars* film. Should this teenager be able to express a preference for not having a private moment seen on the Web and should a site allow other people on the Web to know of and respect those wishes? Should Webmasters comply with requests to remove embarrassing content because it is the right thing to do? For those who post

MARTIN PATIENCE
A VIEW FROM THE PROFESSION

Martin Patience, a BBC correspondent in Kabul, Afghanistan, discusses how ethics applies to his work as a journalist.

The need for balance in coverage

When I covered Lebanon, I was working online. I was quite lucky and I felt relatively happy there because there was another online reporter in Israel and it was kind of perspective driving. The reporting was not necessarily balanced up in my piece. It was balance over two pieces. I did one piece from Lebanon and they did another piece from Israel. I am just a big believer in perceptions…it drives people bonkers. I think normally people understand what the hell is going on if I understand what people are thinking. I don't think there is enough done about it. Just because you give somebody some time to explain why they are doing things does not mean that you are agreeing with them. It drives me nutty. The truth of course matters, but what drives events are perceptions of that truth. Everything is about perceptions. That is what drives things. I would much rather do two pieces, one in the West Bank about a village surrounded by settlements and what they are thinking of the settlements, and the next day go to the settlements and ask what they think about the Palestinians. I think you learn so much more from that rather than, the Israeli government says this, Palestinians say this, and the International Law Code says this.

I think ultimately you have to balance out your reporting over a year. In terms of 95 percent of your articles are in the Palestinian perspective and only 5 percent in the Israeli then something has gone far wrong. Again, it was fascinating during

content, how much should we take into consideration the wishes of our subjects? In the case of the *Star Wars* kid, this teenager became depressed and dropped out of high school after this video went viral. He and his parents sued the kids who posted the video, saying that the *Star Wars* kid had to "endure, and still endures today, harassment and derision from his high-school mates and the public at large." The families settled out of court.

The BBC reported that the video had been seen 900 million times. Other reports state more than 1 billion hits, making it the most-watched online video. The video also spawned new creations such as an animated sequence based on the original or the original embellished with music and text or edited into scenes from the *Matrix* and *Lord of the Rings*. It even spawned mass media attention from comedy shows such as the *Family Guy*.

the Lebanon war in terms of the story. The story was Lebanon. That was the story. The story in Israel really developed in terms of the rockets just keep on coming. If you have done bunkers for three or four days there is only so much you can do about it. In Lebanon it kept developing. First of all you had spectacular pictures of the bombing campaign. Then you had people fleeing their homes. Then you had aid convoys trying to move South. The Israeli side was different. It was kind of the same from the 5th day on.

Bias in reporting the Israeli–Palestinian conflict

Generally speaking I think our coverage is pretty balanced. The perception was the BBC was incredibly pro-Palestinian, you could say of the Americans, I used to work for *USA Today* there actually, you could say that the Americans are more pro-Israeli and that the truth somewhere lies in between. It is difficult. I covered the Lebanon war. I remember getting back and some Palestinian girl said to me, "I thought your coverage in Lebanon was absolutely disgusting." She had a point because initially everybody was in Israel when the war broke out. It was purely logistics. If you can't get people into some place then you are going to tell the story from the place where you can. Certainly in the first few days when you have 80% of the international media in the Middle East in Israel, there was a clamber to get on air with any other story. Beirut was a two-day journey. The northern border was three hours in a car. I spent two weeks in Lebanon and two weeks in Israel. Again, it was all perspective I thought it was worst in Israel than it was in Lebanon…in terms of there were rockets going everywhere. In Lebanon…Israeli strikes you knew that if you were in a specific area you were going to be killed, but if you were out of those areas then relatively speaking you were safe. It is often logistics that make things appear biased because of where you are based, that is the story you are able to tell.

Altering Original Content to Create New Works

The *Star Wars* kid highlights how quickly information can go viral and derivative works can pop up. The meme Epic Beard Man is another example. On an Oakland bus in February of 2010, a confrontation between a 50-year-old black man and a 67-year-old white man with an Ernest-Hemingway-like beard was recorded on a cell phone and posted on YouTube. The fight has racial undertones, perhaps one of the people is under the influence, perhaps the other has a mental illness. Within the first twenty-four hours, the video amassed more than one million views and spawned countless conversation threads. Within two weeks, a high-production-value documentary had been created with the primary subjects, traditional media interviews conducted, parody movie posters created, and

AN INTERVIEW WITH LIZ PALMER
A VIEW FROM THE PROFESSION

Liz Palmer is a London-based correspondent for ABC News

Emotions and live news

Live television has always demanded people react emotionally. Think back about how much we loved the blooper tapes of live television in the 1950s. We loved to see genuine human emotion. I think television likes genuine human emotion. I think television exposes a lack of human emotion brutally. I think that is why it is such a difficult medium for politicians. I always like myself better live than more formal television. When I am building my pieces, if I can I would much rather see me in a spontaneous interaction with a character in the piece than standing there going "blab la bla" to the camera straight on. I basically hate the construct of a stand-up. It is formulaic and I think it's an easy way out. I like doing live television. I like myself live better and I am very comfortable with it. I think I have a natural conservatism or reserve…I don't over-emote. I am also pretty comfortable letting my mature reaction shine through.

I covered the terrible situation in Assetia when the Chechnyan terrorists took 1,000 people hostage in the school. After it was all over they laid the bodies of the children out in the grass. A lot of children who came out of the school were rushed away to the hospital. Some of them had their name scrawled on their chest in marker. People would shake them and say, "what's your name?" and write it because they knew they were being flung into a vast post-communist hospital system. They were going to be unconscious. The children were disappearing into this hospital system with very little to identify them. The bodies that were left, the dead children were on the grass. The parents were coming in lifting

the scene analyzed for its implicit social issues. The older white man has been dubbed "Epic Beard Man." After the fight, the bleeding African American man says "bring an ambulance," and the online discussion follows that due to the facial injury this is misheard as "bring M&M's" or "bring Amber Lamps." T-shirts are created and sold with both of those phrases. The woman who videotaped the fight said in a subsequent interview that both of the men seemed to have been under the influence of drugs or alcohol. The woman who shot the video also encouraged the black man in the video to "beat his white ass." A later interview with the Epic Beard Man resulted in his stating things that did not happen during the fight on the bus and an ensuing discussion of whether he was mentally stable. Privacy law often hinges on the notion of a reasonable expectation of privacy. There are places where we do NOT have reasonable

the sheets. I know what they were thinking. They were hoping not to see a face they recognized. Every one of them…you could see them take a deep breath, bend down…I was so moved by it. I remember talking about it and I know that my voice was shaky. I described it because I knew every parent in America would be able to identify with that moment. I didn't feel afterwards…embarrassed about it. In fact, we won a couple of big awards for our reporting at that event, and I think it was because we allowed ourselves to be human during that event.

Arguments of bias

I think what happens to me is that I am moved by human suffering. If it shows, and it happens to be a human being of one side or the other suffering, then that will be interpreted as biased. In the Middle East, I guess I have always been roughly aware that…your test for being unbiased is that you get as many complaints from one side as the other. It is not something I worry about. I probably worry about it less now because I am older. I have been around enough that I don't feel as if I am manipulated very easily. I know that…I cover Iran a lot. Iran is not what American thinks it is, or what the cartoon image is in America. To understand Iran and to try and interpret it as a subtle place where real human beings have… for example, a lot of Iranian women…although they hate wearing the hijab but they are engineers, IT consultants, and doctors…and they go ok they will make me wear this scarf, but I have a job and a life. For me to report that women aren't driven mad by their veils…some women's groups in the United States interpret it as biased against women. I think most of the time when I am reporting subtleties of a story that people have reduced to black and white…they don't want to see the simplicity busted up. They want it in black and white. If you go in and actually look at all these shades of gray there. You get a lot of negative reaction. In a lot of ways good journalism is a constant battle against that human need for simplicity and clarity.

expectations of privacy, but we might want to offer it to folks anyway. Are the subjects of this video afforded the humanity and dignity they deserve?

Fair use would allow for many of the derivative works surrounding *Star Wars* Kid and Epic Beard Man. So once again, many of these questions are ethical rather than legal.

This leads to discussions of what is appropriate when manipulating and editing images. How much should we allow regular people to retain control of their image and reputation? What things do we need to consider as we alter images and sound for our productions?

Another significant issue is taking things out of context. *The Simpsons* illustrated this concept with an episode where Homer attends a candy convention and smuggles out a rare gummy Venus de Milo. Feminist graduate student Ashley Grant is babysitting Bart and when Homer gives her a ride home she sits on the gummy. As she exits the car, Homer sees the gummy stuck to Ashely's pants and takes it, causing Ashley to run from the car and charge Homer with sexual harassment. When *Rock Bottom,* a tabloid news show, asks to interview Homer he agrees in order to clear his name. The interview is heavily and poorly edited into a totally inaccurate segment complete with a clock in the background with hands that flip around after each word taken out of context and edited into a damning confession. This is an extreme example of the power of editing. But it cautions the content producer in significant and important ways. Editing is a powerful tool. It can make things appear like something they are not (see sidebar), link unrelated images through juxtaposition or take away important elements in a scene that provide the necessary context.

> How much should we allow regular people to retain control of their image and reputation? What things do we need to consider as we alter images and sound for our productions?

Since we've already established that the law tells you what you can do and ethics tells you what you should do as well as some potential areas of concern, media content producers need to practice within ethical boundaries in cases where the law allows something that is not ethically sound. What guides us in making those ethical calls?

Scholars and practitioners offer great suggestions on the ways to make good decisions in a variety of situations. A few of them are highlighted in sidebars throughout this chapter. Professional organization standards are also good places to consult for guidance on ethics and visual images. What is acceptable in public relations may

not be okay at a newspaper. On the following page are some links to professional organizations and their codes of ethics. There, you can get a better idea of the ethical expectations in your specific field.

CHAPTER QUESTIONS

1. Find some basic information on the Westmoreland vs. CBS case, where Westmoreland complained about how he was visually represented in the CBS documentary, "The Uncounted Enemy." Apply the Potter Box analysis to the visual representations in the film.

2. Discuss how you would handle offensive comments posted anonymously on a newspaper Web site?

3. Discuss photo manipulation that is appropriate versus manipulation that crosses the line. How might this standard differ according to medium and audience?

ON THE WEB
RESOURCES ON ETHICS

Advertising
www.aaf.org/default.asp?id=37

Anthropology
American Anthropological
Association
www.aaanet.org/committees/ethics/
ethcode.htm

Art
College Art Association—Art
www.collegeart.org/caa/ethics/prof_
pract_artists.html

College Art Association—Art History
www.collegeart.org/caa/ethics/
art_hist_ethics.html

Broadcasting
Here is an evolution and discussion of
the current code for broadcasters
http://web.missouri.edu/~jourvs/
rtcodes.html

Folklore
American Folklore Society
www.afsnet.org/aboutAFS/
ethics.cfm

History
American Historical Association
www.historians.org/pubs/free/
professionalstandards.cfm

American Association for
State and Local History
www.aaslh.org/ethics.htm

Human Services
National Association of Social Work-
ers
www.socialworkers.org/pubs/code/
code.asp

Journalism
Society of Professional Journalists
www.spj.org/ethics.asp

Marketing
http://www.dsa.org/ethics/

Oral History
Oral History Association
www.ac.wwu.edu/~ccfriday/tools/
Oralguide.htm

Oral History Society
www.ohs.org.uk/ethics/ethics.html

Political Science
The American Political Science
Association
www.apsanet.org/section_513.cfm

Public Relations Society
of America
http://www.prsa.org/_About/ethics/
index.asp?ident=ethl

Psychology
American Psychological Association
www.apa.org/ethics/

Sociology
American Sociological Association
http://www.asanet.org/about/ethics.
cfm

International Sociological Association
www.ucm.es/info/isa/about/isa_
code_of_ethics.htm

5 Law: What You Can and Cannot Do

Democratization of the media means that many more people can be filmmakers, bloggers, Web site creators, and reporters. Anyone can do it, but to succeed you need solid design and execution and also to be able to maneuver some tricky legal issues. For example, if you create a Web site and allow public comments, are you legally responsible for the things people say? What if you are just doing the project in your class, can you pull anything from the Internet to use? What if you want to enter that class project in a contest or a festival or put in on the Web, and you've photographed people in parks without their permission? Digital media production is rife with legal issues. Understanding the law helps you stay out of trouble. This chapter outlines some of the major legal issues that you might encounter as you start your digital media projects including access to information, privacy, defamation, and copyright.

A Timeline for Media Law Issues

Access to information and relationships with sources will be discussed first because they are legal issues you might encounter during the information-gathering process. Libel and privacy will be discussed next as potential legal ramifications of the content you make public because of factual errors, in the case of libel, or too much coverage, in the case of privacy. Copyright issues will be the last thing discussed because these issues are pre and post publication. That means that some copyright issues might pop up as you are putting together your project. When you've finished it and want to share your creation, there will issues that surround protecting your own intellectual property, that is, your finished product.

> **KEY TERMS**
>
> consent forms
>
> copyright
>
> fair use
>
> intellectual property
>
> libel
>
> licensing
>
> privacy
>
> trademark

Access to Information

All kinds of media projects require access to governmental informa-
tion. Artists might use public documents related to torture as part
of a digital art project on human rights. Documentary filmmakers
attend trials to follow major events in their subjects' lives. Fiction
filmmakers attend public environmental meetings to get a feel for
issues in their films or to research a character's motivation. Public
relations or marketing professionals request government-collected
data in order to pitch their products or services to interested parties.
Society for Professional Journalists Freedom of Information Com-
mittee Chairman and University of Arizona faculty member Dave
Cullier said, "One SPJ study shows that a third of news stories that
you will find on the front page are based on public records in some
way. They are crucial. Most of the Pulitzer-Prize-winning work that
leads to change and great reporting is based on public records. You
can't do your job without them."

Clearly there are many uses for such information; so what
type of legal protection exists for access to trials, documents and
meetings?

Although a historical precedent exists, the United States Su-
preme Court has not been explicit in recognizing a First Amend-
ment right to obtain government information. However, judicial
statements have hinted at this right. Justice Potter Stewart said that
the Constitution is "neither a Freedom of Information Act nor an
Official Secrets Act."[1] Supreme Court
Justice Byron White wrote in the fa-
mous *Branzburg v. Hayes* case in 1972,
"Without some protection for seek-
ing out the news, freedom of the press
could be eviscerated." At the same time,
courts have said that the media do not
have any more right than the general
public does to gather information. Gen-
erally, if the public is not permitted to
be somewhere or have access to infor-
mation, then the media are also restrict-
ed. This rationale was demonstrated in
1978 in a case involving media access
to prisons and to inmates (*Houchins v.*

> " One SPJ study shows that a third
> of news stories that you will find
> on the front page are based on
> public records in some way. They
> are crucial. Most of the Pulitzer
> Prize winning work that leads to
> change and great reporting is
> based on public records. You can't
> do your job without them. "
>
> **DAVE CULLIER**
> SOCIETY FOR PROFESSIONAL
> JOURNALISTS FREEDOM
> OF INFORMATION COMMITTEE
> AND UNIVERSITY OF ARIZONA
> FACULTY MEMBER

1. "Or of the Press," 26 *Hastings L. Rev.* 631, 636 (1976); *Houchins v. KQED*, 438 U.S. 1 (1978).

KQED). The media were granted no special access, even when prisoners asked to be interviewed.

The most explicit rights for the public and press are statutory, that is, they come from laws passed by Congress. The general idea behind these laws is that democratic governmental decision-making should take place in the open, and government records should be open for public scrutiny. These rights belong to the general public as well as to the media. These laws are often called "sunshine" laws because they open government to the light of outside scrutiny.

The Freedom of Information Act (FOIA) was passed in the mid-1960s and was designed to open records and files that had historically been closed to public inspection. It covers virtually every unit in the executive branch except for the president and his immediate staff. It covers regulatory agencies and departments such as the justice and defense departments. It does not cover legislative or judicial branches, however many Judicial and Legislative Branch records may be found through the National Archives.

The FOIA mandates that all government information generated by executive branch agencies must be disclosed except for material fitting within nine specific exemptions—like matters of national security, law enforcement, or personal privacy. However, the exemptions are still framed in favor of disclosure, meaning not releasing the documents is permitted, not mandatory. The decision remains at the discretion of the executive agency based on its assessment of the privacy risk. State laws have followed, although more slowly. Prior to 1940, only twelve states had substantial public access laws, but by 1992, all states and the District of Columbia recognized this right. Although all states have some type of law, these state statutes vary greatly in definitions of "public record" and "openness." You'll want to check out the specific laws for your state.

> Access laws are often called "sunshine" laws because they open government to the light of outside scrutiny.

The FOIA has been amended several times since it was enacted in 1966 and more recently has had to adapt to a digital world. As more and more records were kept and requested in electronic formats, some government officials said that these records were not covered under the FOIA. In response, Congress passed The Electronic Freedom of Information Act (EFOIA) in 1996, which outlined the same standards of disclosure for electronic records that apply to paper documents. This includes all e-mail correspondence. The EFOIA required agencies to publish an online index of the doc-

uments they have and to make a reasonable attempt to provide documents in the requested format (that is, on tape, disc, paper, etc.) The law does not define electronic information though, and this can be the crux of the issue when you are seeking information. At the end of 2007, President George Bush signed the OPEN Government Act of 2007 calling for each agency to designate a FOIA public liaison and the creation of an Office of Government Information Services to offer mediation services to resolve disputes. Because documents are often released with information removed, this new law requires agencies to specify the specific exemption for each deletion, called redaction, in disclosed documents.

In your creative work, you'll not only want access to documents but also to meetings and proceedings. The Sunshine Act of 1976 provides that access. There are two general requirements—agencies must provide advance public notice of their meetings, and agencies must conduct those meetings openly. Like the FOIA, the Sunshine Act only applies to the executive branch of the federal government and federal agencies headed by two or more members such as the Federal Trade Commission and the Federal Communication Commission. Congress, the legislative branch, is not included under the Sunshine Act. Congress decides the openness of its hearings on a case-by-case basis but usually decides for openness, likely because it looks better to their

> In your creative work, you'll not only want access to documents but also to meetings and proceedings. The Sunshine Act of 1976 provides that access.

constituents. State and local governments are usually covered by a state version of an open meetings law.

There is a general presumption of openness when it comes to criminal proceedings and related documents in the United States. So before excluding the public from a criminal proceeding, a court must show that closure is necessary to protect a compelling governmental interest and make the closure no broader than necessary to protect that interest.

In summary, there are clear and specific laws that provide access to documents, meetings and trials. These laws are not specific to the press but rather apply to everyone. Use these laws to help you create richer media content.

Relationship with Sources

You've likely seen, heard, or read a media account that cited a "senior White House official." Often, this is a source that has been promised confidentiality by the person writing the report. When promising confidentiality to a source, the reporter needs to consider how far he or she is willing to go to keep that promise. The case of *Cohen v. Cowles Media*, which spent a decade in the legal system from 1982-1992, showed that if a journalist makes a clear promise of confidentiality and the source relied on that promise to his or her detriment, then the source deserves redress for suffering as a result of the broken promise. This is based on the concept of Promissory Estoppel, which is an old legal rule designed to protect people who are harmed when a promise is broken, but the promise itself doesn't amount to an enforceable legal contract. So even if you don't sign a formal contract promising confidentiality, your verbal agreement might be enough to trigger a Promissory Estoppel case. Although cases such as these are not common, they underscore the caution one needs to exercise when promising confidentiality to a source.

Legal problems can also arise when courts want the notes and background information about the people you talk to for your media projects. You can be required to testify in court

Legal problems can also arise when courts want the notes and background information about the people you talk to for your media projects.

and forced to name anonymous sources or be held in contempt of court, which might mean jail times and fines. Another area of concern for content producers is when officials want your notes, photos, or videotape. Usually, the person who created the content is served with a subpoena, which is a legal order that forces a person to testify or to produce documents or physical evidence. Often, journalists in particular are concerned about this because it is likely to hinder the free flow of information, and it can complicate source relationships, especially when dealing with confidential information. Journalists do not want to be seen working for law enforcement because it might stop sources from talking to them. Also, it would be difficult for journalists to appear frequently in court, which takes time away from doing their jobs.

Many journalists try to claim "reporter's privilege" to protect their sources and information. This is similar to the protection given to attorneys and clergy. However, the Supreme Court ruled in 1972 that no reporter's privilege exists, and that, when subpoenaed to testify, reporters must comply (*Branzburg v. Hayes*). This ruling

comes from four separate cases that are collectively known as *Bran-zburg*. Two cases involved one reporter who interviewed drug deal-ers and users and witnessed the making and selling of illegal drugs. The other two cases involved reporters who covered the Black Pan-thers, a controversial black militant party founded in 1966.

Branzburg is significant because it established that journalists do not have an absolute constitutional right to resist subpoenas and said that journalists must comply with relevant grand jury subpoe-

KELLY CARLTON
A VIEW FROM THE PROFESSION

Kelly Carlton is Creative Director and Vice President of DevaStudios, a design company specializing in motion design for theatrical trailers and television spots, main titles for feature films, game advertising and corporate logos. The company has produced materi-als for films such as *Despicable Me, How to Train Your Dragon, Megamind,* and *The A-Team.* In an interview, Kelly shared how the law influences his daily work.

Surprisingly, we spend a lot of time on legal and ethical issues. More than one might expect from a motion design company. As a Creative Director it is my responsibility to constantly be aware of any potential legal issues regarding copyright infringement or usage rights that might pertain to images, fonts and textures that are used in any commercial project.

One example of this was the main titles we created for a movie called *In-hale,* which used an x-ray image of a chest that we pulled from an internet site that was a well-known resource for free-to-use unlicensed images and textures. When it came time to deliver the final piece, we did some research into how we could obtain proof that the image was really public domain, and we found out that it had been obtained through Ebay, and there was no verification on who actually owned the image in the first place. Potential would exist for someone to come forward and identify that photo and sue for its use in the film. Luckily, an employee of DevaStudios had recently received a chest x-ray, and she possessed the digital copies that were a suitable substitution.

Another example of legal issues we deal with is the protection of content, since a lot of the work we do is highly sensitive. I have to make sure that any content is safe from hackers, theft, and even safe from individuals divulging the specifics of anything that we have in-house. If someone tells a friend that he is working on a particular project and describes the details of that project, then the risk is there for someone to describe the information on a blog site. This would spell trouble for not only us but the client who has spent countless hours and dollars moving in a marketing direction that has now been compromised. A negative outcome in a situation like this would easily bring down any small company.

nas in situations similar to *Branzburg*. The Court, however, did suggest that a qualified reporter's privilege might exist. Although inconsistently applied, this privilege has been interpreted by some state courts to mean that journalists can be forced to testify only when the information is relevant to the case at hand, when there is no other way to obtain the information, and when there is an overriding and compelling state interest in the information. It is easier for a reporter to assert privilege and refuse to testify in a civil case. Criminal cases have a competing interest—a defendant's right (Sixth Amendment) to compel testimony on his or her behalf.

> When required to testify, journalists generally face the choice of compliance or contempt, with the possibility of jail time accompanying the latter option.

The press has generally been unable to convince judges that it has an important interest at stake when it refuses to cooperate with people who seek information that has not been kept confidential. Typically, if the confidential information is disclosed to someone else (family member, etc.), reporters can actually accidentally waive their privilege. The idea is that if you promised confidentially and then tell a third party, you've already violated the confidentiality agreement. Some papers have special rules that forbid reporters from telling anyone outside the newspaper the name of a confidential source. Still, when required to testify, journalists generally face the choice of compliance or contempt, with the possibility of jail time accompanying the latter option.

Journalists also seek protection at the state level through state shield laws. Thirty states have shield laws, and their protection varies widely. Some shield laws provide protection only in certain arenas—before grand juries only—while others apply to virtually any government demand for information. Some shield laws will only protect confidential sources of information, while others will protect the information itself. Some protect only information obtained by confidential sources; others apply to evidence that journalists witness first hand. Some grant protection only to regular employees of the traditional news media; others extend protection to both employees and freelancers in a broad range of media. In some states, disclosure of any portion of confidential information waives privilege.

Shield laws received renewed attention in the past decade with some long jail terms and prison sentences. *USA Today* reporter Toni Locy faced personal fines as a result of her refusal to identify her

sources for stories about a former Army scientist under scrutiny in the 2001 anthrax attacks.

U.S. District Judge Reggie B. Walton said Locy must pay fines of up to $5,000 a day out of her own pocket as long as she continued to defy his order that she cooperate in scientist Steven J. Hatfill's lawsuit against the government. The judge specifically prohibited a third party, such as the newspaper or family and friends, from paying the fines. The U.S. Court of Appeals for the District of Columbia Circuit later issued a stay and suspended the lower court order. Locy did not pay fines and did not reveal her sources. "It would have wrecked my retirement if I had," Locy said. "My story was absolutely accurate. There wasn't a comma out of place, but that doesn't matter. My story was totally true. But that does not matter if a judge is trying to compel you to give up information."

> Shield laws received renewed attention in the past decade with some long jail terms and prison sentences.

Freelance journalist Josh Wolf holds the record for the most time spent in jail for refusing to comply with a grand jury subpoena ordering him to testify or turn over video outtakes that he shot of a demonstration that turned violent in San Francisco in 2005. He spent seven months behind bars and was released after reaching a deal with prosecutors where Wolf did not have to testify before the grand jury but did turn over video outtakes although he was not required to identify people who appeared in his video.

Author Vanessa Leggett spent 168 days behind bars in 2001 for refusing to comply with a subpoena to turn over her notes, which included conversations with confidential sources, about a high-profile murder case she intended to write about. Perhaps the most high-profile case was that of *New York Times* reporter Judy Miller who spent eighty-five days in jail for refusing to name a source in an investigation to determine who leaked the name of CIA agent Valerie Plame.

Another journalist in Rhode Island sat under home confinement for criminal contempt of court for not revealing a source. This case began after WJAR-TV reporter Jim Taricani in Providence received a videotape from a confidential source. The videotape, aired by WJAR in February 2001, showed a former Providence City Hall official taking a bribe from an undercover FBI informant in a sting dubbed "Operation Plunder Dome." Taricani refused to reveal the source of the videotape and was convicted and sentenced to six months of home confinement. He was released two months early.

Critics of these authors and journalists say they are obstructing justice and interfering with criminal proceedings. Their defenders are concerned about jailing people who write about true and lawfully obtained information. At press time, a federal shield law was under consideration in Congress, and President Barack Obama was on record as saying he would sign such a law.

Issues That Arise after Publication

Defamation: If you create a Web site and allow public comments, are you legally responsible for the things people say? What if what they say about someone is not true? What if you get something wrong in your reports? When covering stories that involve people's lives, sometimes the media get the story wrong, and these false statements injure reputations. The law offers a redress from these injuries if someone sues you for libel.

Many people use the terms libel or slander interchangeably. Libel pertains to written words that tend to injure a person's good name or diminish how that person is viewed in society. Slander, on the other hand, identifies spoken words that do the same to an individual's reputation. Slander was more of an issue at the formation of the country when injury to reputation was more likely to occur from public speeches than from mass media accounts. Today, even when words are broadcast, they are considered to be libel, rather than slander.

In order to prove libel, the person claiming libel needs to show that false defamatory information that identified the person and harmed her reputation was published in the media. Let's break apart the definitions here to make this clearer. Defamatory content is something that would tend to injure someone's reputation. Typically, this is information that calls into question a person's character—honesty, integrity, professional competence, sanity, morality,

> In order to prove libel, a defendant needs to show that false defamatory information that identified the defendant and harmed the defendant's reputation was published in the media.

etc. The information must also be a false statement of fact. The ultimate defense to libel is truth. If something is true, it cannot be libel. The information has to be communicated to at least one person, which is clearly not an issue with the mass media. The defendant must also show that others who saw or read the information knew

it was about the defendant; it does not have to specifically name a person.

The elements of libel seem pretty clear-cut, which would suggest that many people win libel suits. Because when you create Web sites or report news, mistakes do end up appearing in print, on air, or on line. It seems then that those who are covered by the press often—like public officials—would have an endless steam of lawsuits. If there were, they might "chill" the media, making them shy away from covering certain stories for fear of being sued.

These were the issues of concern when the Supreme Court heard the most famous libel case, *New York Times v. Sullivan*. This landmark 1964 case established some "breathing space" for the press to do its job, even it means that sometimes they get it wrong. In the Sullivan case, the Court set up a standard of fault for false statements made about public officials that allowed journalists to get some things wrong without punishment. The "actual malice" standard of fault demonstrates that for a public official to win a libel case, he or she must prove that the reporter knew the information was not true and reported it anyway or did nothing to find out if it was true.

In a series of cases after *Times v. Sullivan*, the courts helped clarify actual malice. Courts have said that the press should have reason to doubt the truth of the information for reasons such as unreliable source, selective investigation, and deliberate avoidance of crucial information and sources. The courts will often take the following factors into account in determining reckless disregard:

- Was there time to check out the statement?
- Was the source of the statement reliable?
- Was the substance of the statement probable or did it suggest a need to check further?

The press is further protected from libel by a "qualified privilege" that protects journalists when reporting defamatory comments by public officials who are acting in an official capacity as long as the stories are fair and accurate. This prevents the chilling effect of reporting on press conference statements that may be libelous.

Although libel in one of the more decided areas of communication law, a new wrinkle in libel law is playing out specifically in the online world. Anonymous posting online in blogs or newspaper comment pages is the newest area of legal concern. The is-

sues arise when an anonymous blogger posts information that has legal ramifications. The identity of the speaker is key to a lawsuit. If you've been defamed and want to sue the person who told the lies, you have to know who they are in order to sue them. In fall of 2009 a Manhattan Supreme Court judge forced Google to unmask an anonymous blogger who was being charged with libel for comments posted about a fashion model on the "Skanks in NYC" blog, which was hosted by a Google subsidiary. The court rejected the blogger's claim that blogs are simply a modern-day space for sharing personal opinions and sometimes rants, and these should not be regarded as fact. The fashion model who said she was defamed dropped the suit. The Google privacy policy clearly states that the company will comply with court orders for information:

> A new wrinkle in libel law is playing out specifically in the online world. Anonymous posting online in blogs or comment pages are the newest area of legal concern.

> Google will release personal information when it is reasonably necessary to (a) satisfy any applicable law, regulation, legal process or enforceable governmental request, (b) enforce applicable Terms of Service, including investigation of potential violations thereof, (c) detect, prevent, or otherwise address fraud, security or technical issues, or (d) protect against harm to the rights, property or safety of Google, its users or the public as required or permitted by law. The blogger has threatened to sue Google for invasion of privacy, which is another serious issue for media practitioners.

The blogger has threatened to sue Google for invasion of privacy, which is another serious issue for media practitioners.

Privacy. In addition to concerns about protecting reputation, people who are covered by the media are also concerned with protecting their privacy. Privacy is a hot new buzzword. Every year, numerous states propose and pass privacy-related bills. Virtually every Web site now has a privacy policy describing how information collected will be used. And with the rash of anonymous speech on the Web and now the potential to unmask anonymous speakers with court orders, privacy is also an issue for the content producers themselves and not just the targets of content producers.

The right to privacy is not included in the Constitution, but it has been considered to be a part of the "penumbra of rights" in the Constitution. This means that although the Constitution does contain the word privacy, that right is implicitly granted. Privacy law

consists of four areas: appropriation, false light, intrusion, and pub-
lic disclosure of private facts.

The first area of privacy works like a property right. Appropri-
ation is an area of law germane to artists, advertisers, marketers, or
fictional filmmakers. Appropriation is the commercial use of a per-
son's name or likeness without consent. Right of publicity law looks
a lot like a property right because it is the right to make money from
your own name. News is not considered a commercial enterprise, so
this tort rarely involves the news media. Consent is the defense to
appropriation. The person needs to agree knowingly to the commer-
cial use of his or her name or image. So if you are using a person's
name, voice, image or likeness in advertising, you must have their
explicit written consent.

What do we mean when we say use of a person's likeness? In
one case a martial artist hired to model for characters of the arcade
games *Mortal Kombat* and *Mortal Kombat II* said that use of his
name and likeness in subsequently created home video games violat-
ed his right of publicity. Mr. Pesina's movements had been captured
on video, digitized, and incorporated into the games after exten-
sive editing. The district court granted the video creators a motion
for summary judgment in part because the public did not recognize
Mr. Pesina within the game. "[A]fter comparing Mr. Pesina and the
game character, Johnny Cage, who allegedly resembles the plaintiff,
only 6% of 306 Mortal Kombat users identified Mr. Pesina as the
model." *Pesina v. Midway*, 948 F. Supp. 40 (N.D. Ill.1996).

The best defense against claims of misappropriation is a written
release. Fiction and non-fiction filmmakers often negotiate a set of
legal rights often dubbed "life story rights" that enable the author
of the media piece to work with the subject and be free from po-
tential legal action from the making of the film. The fees for these
rights fees vary depending on the fame and attention of the sub-
ject or story. Filmmakers and writers might not seek permission, for

THE LAW IN PRACTICE:
SAMPLE LANGUAGE IN A RELEASE FORM

I hereby assign and authorize (your name) the right (All Rights) in and to my video-
taped likeness for use in an educational DVD. I also authorize said producer, without
limitation, the right to reproduce, copy, exhibit-publish or distribute any such vid-
eotape, and waive all rights or claims I may have against your organization and/or
any of its Affiliates, Subsidiaries, or Assignees other than as stated in this agreement.

example, if the project is made simply from stories in public domain materials such as court transcripts or if there is enough fictionalization as to make the original subject identifiable. Un-

If you invade the subject's privacy, hurt their reputation, want access to any confidential information, or infringe upon their right of publicity, you might be sued.

der the First Amendment, one is generally free to write about other people; these are often marketed as unauthorized biography, without the permission of the subject. This also applies to filmmakers who make unauthorized documentaries, docudramas, or fictionalized accounts of real events. Communication with strong public interest such as news, commentary, satire, parody or critique is protected by the First Amendment. However, if you invade the subject's privacy, hurt their reputation, want access to any confidential information that is not publicly available, or infringe upon their right of publicity, you might be sued.

The second privacy tort occurs in the process of information gathering. Intrusion is different than the other three torts because you can be charged with intrusion whether you publish the information or not. Intrusion is the intentional invasion of a person's physical seclusion or private affairs in a manner that would be highly offensive to a reasonable person. The reason for these laws is to compensate people for the shock and embarrassment of learning that they were observed at a time when they should have been safely out of view from unwanted observation. These cases are not common, and plaintiffs rarely win because of the prevailing question that the court will ask: Was the individual in a place where he or she could reasonably expect privacy?

The courts have said that people cannot reasonably expect privacy in any public place such as sidewalks, parks, beaches, restaurants, and stores. People can reasonably expect privacy in their homes and other private places such as hospital rooms, hotel rooms, dressing rooms, ambulances, private offices, and public toilet stalls. It is important to note that to be "legally" secluded, it is not required that the individual be hidden from all others. But if your plan involves taping in public but in places where people do not expect to be seen such as bathrooms or dressing rooms or taping private conversations with high-tech audio, you are likely to be on the wrong side of this law. And keep in mind, it does not matter what you do with the material after gathering it, the violation occurs in the gathering.

Another privacy tort is the public disclosure of embarrassing private facts that are not newsworthy when such disclosure would

be highly offensive to a reasonable person. This is contrary to libel law in that one can be sued for the dissemination of truthful information. Because this tort surrounds publication of something that is intended to be kept secret, truth is not a defense; it is part of the problem. To prove this tort, the plaintiff must prove that the information was private until the media reported it. The second part of the tort is that the disclosure must be highly offensive to a reasonable person. The question is not whether the plaintiff was embarrassed by the disclosure; rather, the plaintiff must convince the court that it is reasonable to react in that manner. The major defense to this tort is newsworthiness. This comes from a legal acknowledgement that the public has a right to know certain information, even at the expense of an individual's privacy.

> False light can occur unintentionally through juxtapositional editing or the use of generic photos or videos to talk about specific issues.

The final privacy tort deals with information that puts the subject in a false light, and it can occur unintentionally often through juxtapositional editing or the use of generic photos or videos to talk about specific issues. This tort is troubling because it allows redress for content that is completely accurate but because of the combination of elements leaves a false impression. For example, a general shot of students on a campus with a voice-over or text that describes an increase in plagiarism on college campuses might imply that the students in the image are cheaters when that is not the case. So, one needs to be careful when using moving or still images or graphics that imply connections between real people and the issues you are discussing if in fact there is no connection between the two.

Intellectual Property Issues

Copyright: Intellectual property is an area of law that governs creations of the mind and who can own, control, and benefit from those creations. There are three areas of intellectual property: copyright, trademarks, and patents. You could encounter all of these in your digital media work. At times you'll need to pay for use of others' work, but sometimes you can claim fair use for using small portions of someone else's copyrighted works to create your own.

Mash-ups, fan tributes, parody, commentary, humor, and user-created music videos pose an array of copyright issues because

they all rely on using copyrighted material without payment. In fact, shooting video on any city street would mean capturing someone else's intellectual property because there are so many logos and trademarked images in an urban setting. Copyright law is something invoked by copyright holders as well as those who would like to use copyrighted works. As a content producer, you might be interested in using copyrighted material in creation of new works and then also maintaining copyright in the things you create.

American copyright law comes directly from the Constitution (Article I, Section 8), which gives Congress the power to promote the progress of science and the arts by securing limited rights to authors and inventors that protect their writings and discoveries. The idea behind this was to reward the people in society who created things.

Congress enacted the first copyright law in 1790. The laws were revised throughout the nineteenth and twentieth centuries. Current copyright law comes from the 1976 Copyright Act and 1998 Sonny Bono Copyright Term Extension Act. Copyright is given to "original works of authorship fixed in a tangible medium of expression." This includes any original creation that is primarily expressive in nature and is permanent or stable enough to permit it to be perceived, reproduced or otherwise communicated for a period of more than a transitory duration.

The following cannot be copyrighted:

- ideas,
- trivial materials (titles, slogans),
- utilitarian goods (things that exist to produce other things),
- methods, systems, mathematical principles and equations.

Only the expression of facts, and not the facts themselves, can be protected by copyright. An example of this is the phone book. The Court held that despite the fact that a great deal of work goes into this compilation, the creation of alphabetically ordered lists of facts do not qualify for copyright protection.

News stories can be copyrighted. Copyright law protects the expression of the story (the way in which the facts are presented but not the facts themselves). The key to determining whether protection is merited or not is whether there is some originality in the manner in which the facts are organized and selected.

Again, the idea behind copyright is to create an economic incentive for people to create, not to allow the creators to indefinitely

FOCUS ON RESEARCH:
VISUAL BIAS IN COURT PROCEEDINGS

TV images of criminal defendants being led into court create significant and unconscious bias. An experimental study conducted by one of the authors of this book showed that television news portrayals of accused criminal defendants in prison clothes and being restrained by law officers can prejudice the general public more than reporting a person's prior criminal record. People who saw accused criminals in a biased visual manner, such as being dressed in an orange jump suit and wearing handcuffs, evaluated the accused as more dangerous, threatening and guilty than others who saw defendants in plain street clothes.

This study found that even brief video appearances of the accused may cause bias. In the study, the video clips of defendants lasted between eight and fourteen seconds. The bias was retained for two weeks without any more information or images of the accused, and the impression of a defendant viewed in a biased manner remains in long-term memory even when subjects could not remember anything else about the defendant or crime.

The study also showed that visual portrayals are more damaging to a defendant than the disclosure of a prior record. The study reveals a powerful visual bias that causes higher ratings of guilt and threat than reporting a prior record.

In short, the study showed:

- Common portrayals of the accused in television news cause bias.
- The bias comes from brief exposure to the images.
- The bias is retained in long-term memory.
- The people who are biased are unaware that they are.

This bias seems to occur unconsciously from brief exposure before the trial takes place and to remain in long-term memory. This means the steps that a judge might take to ensure a fair trial—sequestering a jury or a continuance to allow time to pass between the crime and the trial—don't work because the bias has already been engrained in people because of media images.

Some policy changes might curb the potential for bias in the media and the courtroom. For example, the jail could offer photo opportunities where the defendant could be photographed wearing street clothes in a nondescript room at the jail. Further, allowing cameras in the courtroom could offer journalists more suitable images of the accused unrestrained and wearing street clothes. Either way, when you create media content that uses people accused of crimes, you should be aware of the potential bias and look for creative video and photo opportunities to accompany your stories.

Barnett, B. (Autumn, 2003). "Threatening and guilty: Visual bias in television news," *Journalism and Mass Communication Monographs, Volume 5 Number 3.*

keep the creations out of the public domain. So there is a limit on copyright.

The length of the copyright depends on when it was created. Once a work is created, it is protected. Work created after January 1, 1978, is protected for the life of the creator, plus seventy years. After that, the work goes into the public domain and may be copied without royalty payments. A "work for hire," such as freelance work, is protected for ninety-five years after publication.

For older works, the protection is shorter. For example, prior to the 1976 revision, works were protected for only twenty-eight years, which could be renewed for another twenty-eight years, totaling fifty-six years of protection. Today, works created before 1976 are protected for a total of ninety-five years but may require a renewal depending on when the original copyright was issued.

Copyright owners are granted almost exclusive use of their creations. One exception is fair use. The idea behind fair use is that a small amount of copying is permitted as long as the publication of the material advances science, the arts or criticism. The 1976 Copyright Act says fair use "for purposes such as criticism, comment, news reporting, teaching (including multiple copies for classroom use), scholarship or research" is not an infringement on copyright.

The four factors judges consider are:

- the purpose and character of your use
- the nature of the copyrighted work
- the amount and substantiality of the portion taken, and
- the effect of the use upon the potential market.

So in other words, when determining fair use, the courts consider if the work is transformed from the original, the type of work you are using, the amount used, and the effect on the potential market. For example, the work is more likely to be considered fair use if not commercial, if it is not a one-use work, if it is informational rather than creative, and if it has been published. However, there are times when commercial, creative works can claim fair use.

The court will also look at how much of the work has been used. This is where students want a hard and fast amount. Sadly, there are no magic numbers or ratios and sometimes it is acceptable to use an entire work. If you use a thirty-second film clip from a ninety-minute movie, that's a very different percentage of the whole than if you use a thirty-second music clip from a two-minute song.

The key question is whether you took only what was necessary to make your point.

For example, in a parody, one is entitled to conjure up the original and can use work more extensively as long as the parody builds on the original. The skits on *Saturday Night Live* or *MAD TV* are examples of this. Further, one can often re-print something in its entirety to comment or criticize. An example here is the reprint of a poem or photograph in a review of an artist. In this case you are re-printing the whole work, but that is the only way to be able to demonstrate the thing you are criticizing.

Digital media content producers often want to use copyrighted works to illustrate larger points, to critique something that is copyrighted, to combine unrelated things to create a new meaning, or to forward or post material in order to facilitate a discussion. You can use small pieces of other's copyrighted works without permission if you take the four factors of fair use into consideration.

You need to make sure you don't limit the audience's taste for the original copyrighted work. The audience needs to see your product as a different thing than the original and not want to buy your work in place of the original copyrighted work. You should only use as much as necessary to conjure up the original, in the case of a parody, or to make your point, in the case of commentary, criticism, and illustrative example. Also, be careful not to take the heart of the work (which is the part that is absolutely central to the work and makes the rest of it worthwhile), and never use the material that you have borrowed to advertise your creative work in the film trailer or print advertising campaigns, for example.

> Once you write or edit your story or create your Web site page, the content is already copyrighted.

Your work is copyrighted as soon as it is fixed in a tangible medium. So once you write or edit your story or create your Web site page, the content is already copyrighted. You don't have to place a copyright symbol or register your work, although the symbol makes that copyright clear to others and the registration allows you to sue for infringement if someone else uses the work without permission and their use is not a fair use.

Trademark. Trademark is any phrase, name, word, or graphic logo used by one manufacturer or marketer to distinguish its products from those of all others. Trademark violations hinge on whether the consumer would be confused about who is endorsing the product. If you want to create a Web site to present your class re-

search on the positive impact of social media on the newspaper industry, you can use Facebook™ or Twitter™ screen grabs as long as people who come to your Web site are not confused into thinking that those social media have endorsed or sponsored your site. However, a re-creation of the CNN Web site might be confused as news from the cable network. Two corporate pranksters called the Yes Men thrive on mock Web sites not as parody but to confuse news producers into interviewing them rather than the corporate counterparts they mimic. Once in the interview, they make outlandish claims as a way to prove their political points. In this case, the Yes Men could be charged with a host of legal issues, however, the negative attention that would be directed to the corporation seems to outweigh the satisfaction the corporation might gain from winning a legal battle.

A humorous recent example of trademark law comes from a case called *Fox v. Franken*, where the FOX cable news network sued satirist Al Franken for the title of his book *Lies and the Lying Liars Who Tell Them: A Fair and Balanced Look at the Right*. FOX claimed that "Fair and Balanced" was its trademark phrase and that Franken could not use it. In order to win the case, FOX needed to show that its news network was so closely related to this phrase, that the average person would see this book and think that it was endorsed by the network. The judge denied the injunction because the book was satire, and the Supreme Court has been quite clear that satire

THE LAW IN PRACTICE:
WHAT IS YOUR LEGAL LIABILITY?

This chapter offers some broad considerations of legal issues that one might face when creating content that will be seen by others. This chapter started with some basic questions. Can you answer them now?

- If you create a Web site and allow public comments, are you legally responsible for the things people say?
- What if you are just doing the project in your class, can you pull anything from the Internet to use?
- What if you want to enter that class project in a contest or a festival or put it on the Web and you've photographed people in parks without their permission?

Being able to answer these questions correctly will be important to you, and when you are a media practitioner, your employer will expect you to know what you can and cannot use legally in your media creations.

is protected speech. The satirist needs to conjure up the thing being critiqued by using the key phrases or logos closely associated with the product. In the end, the lawsuit propelled the book to the *New York Times* best-seller list, prompting Al Franken to comment that the lawsuit was the best thing to happen to the book.

Patents. Patents are only really an issue when you are creating a new product. Then, you'll want to make sure you are not infringing on someone else's creation and that you are protecting your own. Patent law is a complicated area that almost always requires legal help because one must determine if the thing you are trying to patent is, in fact, truly original and patentable content. Some new and exciting developments pertaining to patents include wiki spaces, which allow inventors to see if their invention has already been invented (called a search for prior art) or already in the marketplace. The process also allows inventors to learn from previous inventions and make theirs better, and for those with expertise to share it with others working in the same areas.

CHAPTER QUESTIONS

1. You create a Web site for a non-profit organization. What music, photos and articles can you post on the site and what legal issues must you consider?

2. When creating media messages, what do you need to consider when using images of celebrities? What about people who are not famous? Children? Children of celebrities?

3. What are some of the legal issues posed by untruthful comments said by a subject in a documentary film?

6 Principles of Design

Have you ever looked at a page in a newspaper or a magazine, the graphic of a TV special program, or a Web page when it popped up in your browser and immediately been drawn to an element on the page or screen? Or, have you ever looked at a newspaper or magazine page, a graphic on television, or a Web site and felt lost because nothing stood out? The page consisted of many parts, but none of them seemed to be of more importance than the others, and it was difficult to figure out what you should look at or read first. Unless you were able to scan the page quickly and find something that drew your interest, you probably didn't spend much time with the page's content and quickly turned to another or moved on to a different Web site.

Whether you were immediately drawn to an element of the page or screen or whether you glazed over and didn't spend much time with the page's contents depended more than likely on whether the designer of the page applied principles of design. Media designers—those who create the layout of newspapers, magazines, Web pages, advertising, or any other visual media image—operate with a basic set of principles, just as artists, musicians, and writers do. When you look at a page or an advertisement, something needs to capture your attention. Having something included that pulls you in naturally makes the page or ad more appealing to you when you view it. This is something that rarely happens by accident; it is the result of careful planning.

Media designers know that the contents of a page have value to those who use the specific medium. Knowing their audience, they realize that some things will be of more

KEY TERMS

balance

center of visual impact

emphasis and economy

optical weights

proportion

repetition and variety

rule of thirds

sequence

serif

symmetry

unity

weight

interest to those who use the medium than other information. When designers make choices about visual elements—scale, location, and, proximity to other page items—they emphasize a certain element and then rate the rest of the information accordingly. In doing so they are working with a primary concern of all information design: visual hierarchy. Designers think about what they have to use on the page—copy, images, and perhaps even sound and video—and they then construct the page to utilize all those elements. But, they know that simply using all these elements arbitrarily will rarely attract readers or viewers and practically never hold their attention. Just as in the scenario questions posed in the first paragraph, a hodgepodge of information thrown together without planning will inhibit readers and viewers and make the page of less value to its users, perhaps even causing them to miss important information that they would have noticed had the page been better designed.

> The thoughtful media designer adheres to certain design principles when taking photographs or shooting video or constructing Web pages or print media layouts.

Because design is so important, the thoughtful media designer adheres to certain design principles when taking photographs or shooting video or constructing Web pages or print media layouts. While each of the elements below may be difficult to maintain at all times for all pages in all media, understanding and using them are essential to ensuring that a layout appeals to those who are looking at it in order to obtain information and to understand what is considered the most important information on the page or in the advertisement.

Balance

Most of us prefer that our lives have balance. Most of us do not like living "on the edge." We want order in our lives. The same is true in design. Balance is the first principle of design. Balance has to do with the way you distribute the weight on each side of an image or layout. You give as much "weight" to the left side as to the right side, the top and the bottom. This is called symmetry.

There are numerous ways to achieve symmetry. A symmetrical page in a publication would have the left side and the right side of the page balanced. Doing this occasionally is fine, but having everything balanced in a media design all the time is boring. Yes, we

like balance in our lives, but we don't like looking at symmetrical things often. That's why movies rarely work when they deal purely with "ordinary," everyday life that lacks crisis, turmoil, or something that creates unbalance for the protagonist.

If designers truly want to engage viewers of their visual layouts, they must approach media design through asymmetry. This means that there is a different visual weight to one part of the page that you are viewing. More weight to one side or portion of a page may be accomplished through visuals, color, or typography—something that draws the viewer to that place on the page before anything else. This means that you really shouldn't balance your page such that all areas of the page are weighted equally as to what they contain. Instead you should seek opportunities to build asymmetry into your design. Again, you want to control the order of information that your viewers experience; in doing so you're building a visual hierarchy. You want something that will draw the eyes of the viewer—whatever you consider to be the most important element of the page or design.

Figure 6-1: The photograph of the fireplace demonstrates formal balance, with the two pillows creating a symmetrical balance. Most media design uses asymmetrical balance, such as the pictured Web site, which has a center of visual impact.

When you are adding a visual component to your media page, symmetry is not particularly compelling. Look at the photograph of the fireplace at right. What part of the image immediately captures your attention? There is probably nothing that does. The balance that's present in the image actually works against your visual design goals. It yields a image that isn't dynamic but is instead boring and unexciting.

The Web site homepage represented here has many elements of symmetry included in its design. However, it also has a center of visual impact (to be discussed later) that automatically draws the viewer's attention to the top center part of the page. The large black

box with the image of a young girl is impossible to ignore. The word "watch" almost demands that you do just that—click and watch the video. The elements under the main element of the page are naturally where you look next because they are the next largest elements on the page.

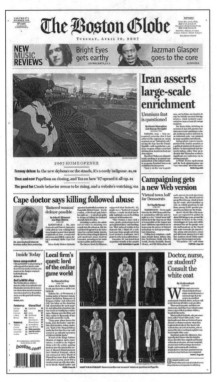

Figure 6-2: In what ways does this page from *The Boston Globe* exhibit balance?

The designers of the page obviously had a plan for viewers when they put together its elements. That was to get you to focus on the top part of the page first, specifically the large "watch" box, and then move to the two lesser but clearly emphasized elements below it. Because of the way we read—from left to right—we would be drawn to "OI Around the World" first because its headline is longer, it's on the left, and therefore more prominent. We would then attend to "OI Panama."

After we looked at these, we would then probably begin exploring the links at the top and the bottom of the page. Each of these provides the viewer with access to important information, but they are not designed to be the first things we notice. The way they are presented gives the page symmetry because what's at the top is roughly identical to what's at the bottom of the page. Imbalance is achieved, though, because we focus on the element of the page that carries the most weight.

Balance, therefore, is achieved through optical weights. This means you will decide the importance of elements, and their placement on the page will lead the viewer through the page. You will, in other words, attempt to focus viewers' eyes where you want them to go—from the most important element to what you consider the least (this is part of the fourth principle, sequence, discussed below). You know what you think are the most important elements and those that are the least important. Arrange them that way on your page.

Look at the newspaper front from *The Boston Globe* on the previous page. Is it symmetrical or asymmetrical? Which part of the page, top or bottom, has the most weight? Is the page balanced left to right? Now, look back at the OI Panama Web site page. Ask the same questions. Both are extremely balanced pages that have enough symmetry to make them comfortable to readers or viewers but enough asymmetry to make them exciting and inviting to those who would use the respective medium.

Proportion

Proportion is something that should work naturally. It is simply arranging spaces in an image or on a page in a pleasing relationship. The bigger something is, the more space it should receive. Book pages are proportional, that is, they have good shape in height versus width. You don't have to have identical size margins on all sides in all types of publications. The same would be true of Web pages. Something may be heavier on the left than on the right.

> Proportion is something that should work naturally. It is simply arranging spaces in a picture or on a page in a pleasing relationship. The bigger something is, the more space it should receive.

Another way to think proportionally is to assume that things that are more important are made larger. Therefore, the more important items are larger than the less important items. Look, again, at *The Boston Globe* front page. What is the most important item? Is it the largest? The most important item should be the Fenway Park photo since it's the largest item on the page. Given that, it should be obvious that proportion also plays into issues of visual hierarchy.

The same is true of the Web site OI Panama. The most important item is the image of the girl. Its box is given the most space in proportion to its importance. Proportion and balance work hand in hand. Because you consider an element to be more important than others, it is given the most space on the page, in the photograph, or in the video you are shooting. If you were interviewing someone who just saved a puppy from a burning building, for instance, you would want to focus in on that person as she was explaining why she did what she did. An image of her talking that had her some distance from the viewer would simply not be compelling. Too much other visual information would be included in the shot, and you would lose the proportional element of design.

Repetition and Variety

Repetition is repeating visual elements to create a pattern. Gestalt psychology tells us that our minds like patterns (and often look for them even when they may not be there). It is pleasing to the eye to find these patterns in the things that you want to photograph and to create them in your media designs. When the Gannett Company began *USA Today* in 1982, for example, it employed the principles of repetition and variety in the newspaper's design. *USA Today* created a clean layout that placed elements in the same position on the page—or with only a little change in size and location of those elements—every day. Note the similarities—the repetition—in the two examples of the front page. The result, Gannett realized, would be a comfortable and attractive paper that ensured that readers would not be taken by surprise in the way it looked. The importance of repetition in design cannot be ignored in *USA Today*'s rise to becoming the highest circulation print newspaper in the United States.

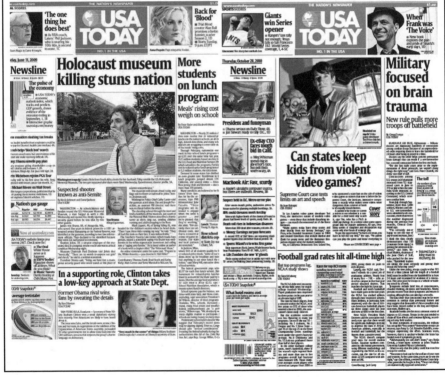

Figure 6-3: *USA Today* exhibits a strong consistency from day to day but with enough variety to hold the interest of its readers.

Even though *USA Today* uses constant repetition of its front-page elements, variety is also a constant in its design. Variety breaks the pattern of repetition and helps to keep viewers' attention. We love for things to be familiar. How often, for example, do you sit in the same seat in a classroom? But, we don't like to look at the same thing over and over. Variety breaks up the monotony and gives us a surprise at times.

What changes on the front pages of these examples of *USA Today*? One obvious answer is the content. That changes daily, so readers never know exactly what to expect in each of the elements of the front page. There is some color change, too. There are other subtle changes, too, like the information in the box above the main headline in the second example.

The same design principles can be applied to any medium and to any photograph. Let's consider the OI Panama Web site one more time. We already know that it uses balance and proportion well. But, how does the Web site employ repetition and variety? Repetition is pretty obvious. Every time a person opens the site, the elements on the page are static. That is, they are positioned in the same place. For people who might use the site multiple times, they will know exactly where to go and where to click to get to the information that they want from the page. But, how is this Web site—or any Web site—able to give its viewers variety? The OI Panama site does this by making the central component of the page—the large black

Figure 6-4: The OI Panama Web site exhibits consistency in placement of links and standing elements and variety by changing the central component of each page.

box that has an image and large headline in it constantly change. Of course, the changes cannot be infinite, but OI Panama offers viewers six changes in the main visual element of the page. Because the images in the box change, because the colors used in the box for the headlines change, because each headline asks the viewer to do something different, variety is achieved while familiarity is maintained.

Sequence

Sequence is an idea that you'll think about specifically with Web or print design, but you can use the concept with any media design. Simply, you do not leave to chance the order in which a reader perceives objects on a page or screen. This concept goes naturally with the idea of balance and proportion. Here are some things to remember:

1. Readers in the Western world generally read from left to right, top to bottom. This element of sequence is used, as we saw, in creating balance in the OI Panama Web site. We are drawn to the large box, but after that, people need to know where to go next. The Web designers made that decision for viewers, though viewers don't realize it. Once we leave the most important element that is proportionally the largest on the page, we move to the next element down and to the left. Presenting the sequence of information this way works because it's how you read. You've learned from a lifetime with books, newspapers, magazines—anything printed—that this is how you read or look at things. That is why the concept is so important and integral to the principles of design.

> Because shapes, colors, and sizes can create viewing paths, a designer can move readers' eyes in a defined sequence all over the page with careful planning.

2. But, readers also move from big to little, black to white, color to non-color, from unusual shapes to ordinary shapes. You can move readers with lines or imagined lines that might do all sorts of things such as extend into another element on the page. OI Panama does this with a large black box that captures your attention before you really pay attention to the elements with a white background. In the bottom third of the page, you look at the unusual shapes of the next-to-the-largest page elements be-

fore moving on to the more usual squares at the bottom of the page or the words at the top that provide links. The lines between them give the illusion of rectangles, a much more common shape than even the globe that is under the main page element. They are also much smaller than the page elements that the site creator emphasized and made larger. So, by creating elements with differing shapes, sizes, and colors, OI Panama creates a sequence that leads viewers through the page.

Because shapes, colors, and sizes can create viewing paths, a designer can move readers' eyes in a defined sequence all over the page with careful planning. Look at this Web page for the *Herald-Sun*. Your eye is naturally drawn to the largest element on the page, a photograph. But after that, is there any sequence to the page? Obviously, there is none. Even though there is a large photo in the top middle of the page, every other element of the page is about the same size, doesn't stand out, has no color that varies from one page element to another, or is not basically a rectangle. There is nothing present to guide the viewer through the page, no way to know whether you should read from left to right and top to bottom with this page. In fact, there is nothing to guide readers anywhere on the page.

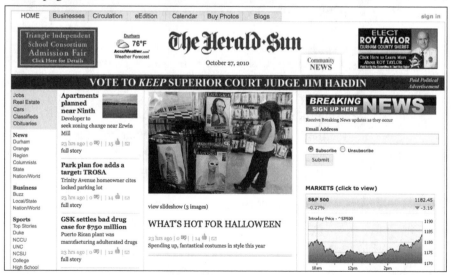

Figure 6-5: This newspaper's Web site offers few visual cues to guide the reader toward what is most important.

Unity

Unity as an element of design deals with harmony. Everything should and must look as if it fits together. Everything in a photograph should feel as if it fits together. In a way, every designed publication or photograph should strive to be its own little piece of art.

There are some specific ways to achieve unity in media design that are not difficult. Some are simply common sense.

1. The font or fonts that you choose to use for headline type and copy type can give your work unity. Bold approaches usually use sans serif type styles. Sans serif type does not look like the type you're reading. It looks like this: **sans serif**. Arial—or Helvetica—is the most common sans serif type. Type that lacks the little lines on the ends of letters is sans serif. The word sans serif is the same type size as the type in which this book is written, which is a serif type. See how much larger it is. When you make it bold, it stands out much more than serif types (a serif **bold**). Using the same type for heads provides unity just as using the same type font for copy does.

2. Avoid using too many different fonts (also known as typefaces) in any one production. Multiple fonts tend to confuse readers. Using too many styles of fonts is a sure recipe for creating a disjointed page.

3. Consistent placement is a way to achieve unity, such as always placing a heading in the same place with the same type font, etc. This is exactly what *USA Today* has accomplished. The repetition of element placement on its pages is complemented by using the same font style for the headlines in every issue.

4. Dramatic shapes are more appealing than squares. Squares can be boring. Images that are much wider than they are tall or much taller than they are wide capture readers' attention. The OI Panama page uses a rectangle, but the horizontal sides of it are much longer than those of the vertical sides. The result is a dramatic shape. Compare the shape from the OI Panama site to the images on the *Herald-Sun* Web page. The image shapes here are close to being squares and much less exciting. Aim for more dynamic images to place on Web pages and in print publications. The same concept would apply to photographs.

Dramatic shapes can easily help you to achieve many of the principles of design. Because of the shape, they easily help you create asymmetry in the balance of your page.

Figure 6-6: By grouping images into a dynamic block, the FL-Jadis site accomplishes a lot with just a few elements on the page.

Dramatic shapes can easily help you to achieve many of the principles of design. Because of the shape, they easily help you create asymmetry in the balance of your page. They are often proportionally larger than other elements, so they take up room and help create the center of visual impact for a page. While a dynamic shape will not give you repetition, it will certainly provide variety, and it will definitely provide you with a starting point to create a sequence of elements on a page. A dynamic shape can often be the unifying element in your design and help tie all the visual content together.

5. Unity is also obtained by using fewer rather than more elements on a page. Fewer elements allow you to group things together that are related. Look at the Web site FL-Jadis above. It contains one large pictorial element that is comprised of four images, a series of four link buttons, a logo, a vision statement, a header at the top, and two commands, "hago" and "puedo" near the bottom. By grouping the images into a dynamic block and the buttons into the feel of one dynamic rectangle, the page accomplishes a lot with just a few elements.

Compare it to the *Herald-Sun* site. There is no unity in design because there are too many elements, none of which differs from any of the others. The person who laid out the FL-Jadis page grouped like elements in a box or by using consistent shape and color. The *Herald-Sun* page is consistent with color in the type and headers, but nothing differs in size. Yes, there is unity in color, but the design principle of variety—or the lack thereof here—trumps the unity achieved through color. Because of the way that the FL-Jadis designer was able to create unity from the few elements within the design, this Web page is much more appealing and unified. Media pages that are cluttered with images and multiple similar elements make it tough to figure out where to look.

Emphasis and Economy

Emphasis and economy are two design elements that should be considered together. With emphasis you want to train yourself, using the terminology of the photographer, to look through the viewfinder and focus on a single visual element. Decide what the focal point of the information is and then focus accordingly.

With economy you'll want to eliminate everything that isn't necessary to communicate the required information. Frame the shot so that all the other things that distract from the focal point are out of the photograph or do not compete with the subject. The quality of the photograph in terms of the elements of design is critical if the image is to be the central focus of your page, which it often is.

Look at the photograph to the left. Think about how or if the photographer has achieved economy and emphasis. What do you think the photographer wants you to focus upon? What do you see in the photo that distracts from the main subject or emphasis? The photographer, if focusing upon the lamp, perhaps did

Figure 6-7: Has the photographer achieved economy and emphasis? Or are the elements competing for the viewer's attention in a distracting manner?

not realize that the tower in the background and the bird would compete with the lamp for the viewer's attention. If something else, like the bird, was the focus, then its size in comparison to the other elements in the photograph keeps it from being the principal emphasis in the picture.

Figure 6-8: How has the photographer achieved emphasis in this picture? Are the woman and the child the focus, or the people in the boat? Photographers make dozens of decisions that determine whether their work will make a maximum impact.

Now, look at the photograph of the woman and child on the top of this page (Figure 6-8). What is the emphasis? Has the photographer done a good job of making sure that the woman and the child are the focus of the viewers? In other words, has good emphasis been achieved? Do the people in the boat compete for your attention, or are they secondary?

The same ideas about emphasis and economy apply to the design of other media. One thing should stand out. That's usually the most interesting or important element on the page. This is the center of visual impact (CVI). The

Figure 6-9: A cluster of elements makes for a compelling dominant element in this photograph, and use of the rule of thirds adds to the strong composition.

woman and child are the CVI for the photograph on the top of this page. Emphasis, then, may be achieved by using elements that are bigger, darker, more colorful, more unusually shaped than the other items in the photograph or in a layout. It's obvious that the woman and child are larger and more prominent than anything else in the photograph. Emphasis may also be achieved by having only

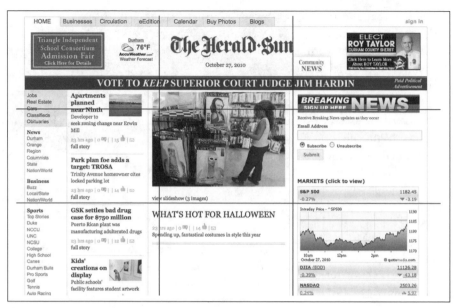

Figure 6-10: The design of this newspaper's Web site has a number of problems, which are made clear when when one considers the rule of thirds.

one item or cluster dominate per page, screen, or Web page. The image of the young girl taking a photo is the dominating image in Figure 6-9 because the cluster of the girl and the woman draw your attention before you notice the man whose picture is being taken. The photographer ensured this by the placement of the girl with the camera in the entire vertical third of the right side of the image.

Professional photographers and media designers also know that people are naturally drawn to certain places in images. As a means of achieving the principle of emphasis, you can apply the rule of thirds. With the rule of thirds, an image is divided into a series of imaginary blocks. Though the lines obviously do not exist on an image or a page, humans are somehow drawn to the areas where the lines intersect.

As a result, emphasis may be achieved by ensuring that the most important element in the image is located at one of the imaginary line intersections. The intersection points also make the balance of the image asymmetrical. Look again at the photograph of the girl with the camera on the previous page. Notice the lines that have been added to portray the rule of thirds. Notice how the girl's body is directly located along the right vertical axis, and the girl's head is also positioned at the junction of the imaginary vertical and

horizontal lines. The rule of thirds can be applied to your designs as a means of achieving most design principles. Notice how the *Herald-Sun* Web page in Figure 6-10 does not work with the rule of thirds, which also reveals, as we have already discussed, that it really does not follow the principles of design very well and, thus, does not supply a compelling or inviting page for viewers.

Putting Perspectives into Practice

These guidelines are just that—guidelines—if implementing all principles of design in your creation won't work, then you, as a visual communicator, should use the principles that best achieve your goals. Using all principles will not be appropriate in everything that you create, but you should strive to include as many of them as possible in your images and layouts.

Remember that simple is often better in media design; less is often more. A few elements per page are better than clutter. This same is true for

> Look at publications, advertisements, Web pages, video, and still photographs to find ideas and concepts that you like.

photographs. Frame the shot to get rid of unnecessary information. You should also visualize what you are going to do before you start. You can do sketches on paper or in your mind, referred to as storyboards if you are creating video or animation. Visualization involves experimenting with how certain fonts will look; how colors, lines, images, etc. will interact with each other; and how these decisions will support the purpose of your media presentation.

Another good idea to adopt is the concept of creative copying. Good ideas are everywhere, and it is impossible to always come up with an original concept. Look at publications, advertisements, Web pages, video, and still photographs to find ideas and concepts that you like. Make a folder of this information to help you come up with ideas that you can use. Unless you copy identically—item-by-item—you're not guilty of plagiarizing. Instead, view this practice as a means of inspiration that will get you to a starting point with your own work. From there, applying the principles in this chapter will help you to achieve great visual designs of your own!

Possible Design Concepts to Avoid

Even though the items listed below can often be used in powerful ways, they tend to produce less compelling results in photographs

and media design. So, think carefully about your purpose before you apply any of the following to your designs: picture cutouts like stars or other shapes, photographs that do not have good content; tilting or turning photos off center, vertical typography, image overlaps, and placing text over parts of photographs.

Having said that these are design elements to avoid, you will, no doubt, be able to find numerous examples of each that work well. It all goes back to the purpose of your design, its target audience, and understanding how the principles of design work.

CHAPTER QUESTIONS

1. How do a center of visual impact and the rule of thirds work together in designs?

2. Why is balance critical to design, and why is asymmetry critical to your images?

3. Pull up your favorite Web site. How did its creator use proportion, repetition, and variety in its design? Or, how could the site be improved by applying these design principles?

4. On the Web page you used for Question 3, determine if its creator considered sequence and unity in the design. If so, in what way was each achieved?

5. Why does it make sense to use fewer elements than more in most media designs?

7 Composition for Still Images

In today's era of camera phones and Flickr, seemingly anyone can be a photographer. In an instant, a dramatic, humorous, or newsworthy moment can be captured in a still image and transmitted around the world via the World Wide Web.

Amateur snapshots have a valuable role to play in today's multimedia world, allowing the public to see events that traditional outlets did not or could not cover. However, media organizations still need the skills of professional photographers, whether they're producing in-depth news reports, glitzy advertising spreads, Web sites for films, or multifaceted public relations campaigns. Plus, amateur photographs could be greatly improved with a little guidance.

"There are three elements that go into making nice pictures: light, composition, and emotion," according to Monty Davis, multimedia picture editor at the *Kansas City Star*. "Great pictures have all three elements."

No matter the purpose, photographers working in the media industry follow a set of composition rules, most of which are based on the ideas discussed in the visual theory and design chapter. A good still photographer will use those composition rules to anticipate how audience members will look at an image and how their minds will interpret what is there.

Whether you're a beginner using a $3 disposable camera or a veteran operating a $3,000 Nikon, the following principles will help you create more effective and memorable photographs.

Apply the Rule of Thirds

Often, beginning photographers place their subject directly in the center of the frame, which usually results in an uninterest-

KEY TERMS

aperature

decisive moment

depth of field

emotional

"golden hours"

graphically appealing

informational

intimate

reflectors

tripod

ing image. Instead, look through the viewfinder and imagine lines dividing the frame into three equal vertical sections, and another set of lines dividing the frame into three equal horizontal sections. The intersections of those lines are where the human eye tends to gravitate and are most often where you should place the focal point of your image.

Notice how the rule of thirds is applied in Figure 7-1 below. Vertically, the woman sitting on the bench is aligned along the intersection between the center and left sections of the frame. Horizontally, the woman's eyes and the top stripe are aligned at the intersection of the top and center sections, while the bench is aligned along the top of the lower third.

Figure 7-1: The placement of the woman within this frame illustrates how the rule of thirds can be applied for effective photographic composition. (Photo courtesy J. McMerty)

Backgrounds and Body Parts

In the visual theory chapter, you learned about the concept of closure—the mind's tendency to see patterns when they are not really there. Sometimes, beginning photographers are so focused on the primary subject that they forget to consider the background, real-

izing to their embarrassment later that their subject appears to have an oak tree growing out of her head, as you see in Figure 7-2 on the right of the page. Or, the photographer puts the subject in front of an overly busy background that detracts from the primary message. Unless you're shooting a breaking news event where every second counts, take a few moments to make sure the focal point of your picture works in concert with what's behind it.

Figure 7-2: Consider your backgrounds.

As a general rule, photographers also should avoid cropping people where they bend—wrists, elbows, knees and ankles in particular. Cutting people at bending places is psychologically unsettling and gives the impression that the rest of the body part might not be there. In Figure 7-3, we would be better off to see the hands or to cut the photo in the middle of the forearm.

Figure 7-3: Avoid cropping at joints.

Get Closer

Wide-angle shots have their place: They can establish a scene and give a sense of scope when used appropriately. Much of the magic of photography though is seeing things that you might normally not be able to view up close. Beginning photographers often make the mistake of not getting the camera close enough to the subject.

"Young photographers rely way too much on wide-angle lenses," Davis said. "They need to train themselves to put on a longer lens and look for nice clean images that have impact and emotion."

Close shots make us feel like we were there, like we know something about the subjects of the photo.

Economize

A documentary photographer should never frame a situation in a way that misrepresents what actually happened. Within those

bounds, your photographs should include only what is impor-
tant to communicate your desired message. Zero in on what is
vital and either keep other elements out of the frame or de-em-
phasize them.

An effective technique to achieve economy involves depth
of field. In short, depth of field describes the apparent focus in
front of and behind the primary point of emphasis in an image.
"The concept is essential because it is a tool for adding empha-
sis," explains award-winning photojournalist Steve Raymer. By
adjusting aperture (the opening in a camera lens that regulates
the amount of light that enters), camera-to-subject distance, and
the focal length of the lens, photographers can create a shallow
depth of field to isolate the subject of a photograph from fore-
ground and background, such as Figure 7-4 on the next page.

In a similar manner, photographers can use the same photo-
graphic tools to create maximum depth of field, which adds con-
text and the sense of place, as in Figure 7-5.

"Wide-angle lenses have built-in depth of field by virtue of
their design," Raymer says "The reverse is true for telephoto lens-
es. As a professional photojournalist, I usually have my camer-
as set at 'aperture priority' to control for depth of field because
this is our essential tool for controlling what is emphasized in-
side the frame."

Light: Magic and Golden

"When I go on an assignment, the first thing I do is look for
the light," says David Stephenson, an award-winning photojour-
nalist who also teaches at the University of Kentucky. "I'm like
a moth. I'm drawn towards it and I seek it out. There is always
light, it just varies in intensity, color, size and direction."

When possible, you should avoid taking outdoor photos
during the middle of the day, when the sun is straight overhead.
No one looks good in this light. Unless you intend to use the
harsh shadows for a dramatic effect, or have no choice in when
to shoot, schedule your outdoor as-
signments during what some call
"the golden hours" or "magic hours,"
when the sun is starting its ascent
or descent. The low sun of the ear-
ly morning or early evening produc-

When possible, you should avoid
taking outdoor photos during
the middle of the day, when the
sun is straight overhead. No
one looks good in this light.

Figure 7-4: The photographer has used a shallow depth of field in this shot to put the emphasis on the running water from the pipe. (Photo courtesy J. McMerty)

Figure 7-5: This shot is composed in a similar way as the previous picture, but in this case a wide depth of field was used to emphasize the building and workers. (Photo courtesy J. McMerty)

FOCUS ON RESEARCH:
ETHICS IN PHOTOJOURNALISM

Newspaper readers recognize and understand that photojournalists have an important job to do and that sometimes their professional responsibility requires them to make photographs of people in desperate situations rather than attempting to rescue or otherwise assist the person in distress.

When documenting human tragedy, photojournalists choose between acting as dispassionate observers and "Good Samaritans." Our study asked whether readers adopt a situational ethics rationale when assessing a photojournalist's decision to make a photograph of a person suffering severe trauma. We examined an extreme situation where a woman in the street was on fire and asked, should a photographer make photos or try to put the fire out?

One might assume that someone taking a non-journalist perspective would say that the right thing to do would be to help. A journalist, however, would likely say, "it depends." In discussing these sorts of dilemmas, journalists generally use situational ethics. Rather than adhering to absolute rules (i.e. "you must help a fellow in need") or utilitarian reasoning (i.e. "how can I do the most good for the most people?"), situational ethics identify the characteristics of a situation upon which the right decision depends.

In our test case, one situation was that the photographer was physically unable to assist because she/he was too far away. Another situation was where there were other people nearby who could provide better assistance than the photographer. And yet another was where the person purposefully put herself in a dangerous situation as a form of political protest.

Using a mixed experimental research design, we tested an extreme news situation using a pair of photographs in which a woman was on fire, and we set up three different situations: either the photographer was close enough or not, either there were others who could help or not, and either the person in distress was the victim of an accident or was protesting against a military dictatorship.

The results were based on the responses of seventy-two ordinary newspaper readers and clearly showed that when readers where asked what a photojournalist should do, a situational ethics rationale was used. In other words they said, "it depends." When presented with situations where the photographer had no opportunity or had other helpers or was witnessing a political protest, the readers were more likely to say "take the picture" than when the photographer had opportunity or had no helpers or was at an accident.

Yung Soo Kim and James D. Kelly, "Reader Reactions toward an Ethical Dilemma Faced by Photojournalists: Examining the Conflict between Acting as a Dispassionate Observer and Acting as a 'Good Samaritan'" *Journalism and Mass Communication Quarterly*, 87 (Spring 2010) 25-42.

Figure 7-6: Using available light from a window, this photographer was able to compose an aesthetically appealing picture. (Photo courtesy David Stephenson)

es a warm, orange light that bathes your subjects. Many movies and magazine shots are made during this brief time. It takes extra planning, but saving your photography for one hour after sunrise, or one to two hours before sunset, will add a richness to your shots.

"If you are in a situation where you can't, or shouldn't, change the lighting, then find where the 'sweet spot' is and wait for the moment to fall into that area," Stephenson says. "In other words, find the light, stay there, prepare your lensing and exposure, and wait. You'd be surprised how often that will work out for you."

You always need to think about how light is striking your subject, even when you are shooting indoors. A common problem when shooting indoors is that you put the subject in front of a window and then the light from the window is too bright and your subject is too dark. However, move to a different position or shoot during a different time of day, and the effect can be striking, as shown in Figure 7-6 above.

"If you find yourself struggling with an interior portrait, try turning out all of the lights," Stephenson says. "See what the windows give you. Then turn the lights back on one at a time and see how the light changes and position your subject so that the light hits them in a pleasing or dramatic way."

If you shoot photographs on a regular basis, Stephenson says relatively low-cost light reflectors are a good investment. These light-

weight panels allow photographers to bounce light off a wall, floor, ceiling, or other object to create subtle changes and softer shadows. "Reflectors are an inexpensive and portable way to have huge, positive impact on lighting," Stephenson says. "Unfortunately they require three hands, but I never hesitate to ask for help from people who are just hanging around watching."

Put the Sun Behind You

When taking photographs outdoors, the sun will be your primary, and often only, source of light. The general rule is to shoot with the sun behind you and to one side. This front lighting brings out color and shades, and the slight angle—called side lighting—produces some shadow to show texture.

Depending on the available light, photographers may use flash fill to bring out areas of shadow in a naturally lit scene. For example, some sports photographers use flash fill to compensate for shadows under the brim of a baseball cap.

Keep It Steady

Often, amateur photographs are blurry, which usually results from the photographer moving the camera.

"Many photographers think they don't need a tripod–that's completely untrue," Stephenson says. "I advise buying a good tripod that you are likely to use. If you own a bad tripod, you won't ever want to use it."

If a particular situation makes it unfeasible to use a tripod, try holding the camera with both hands and resting your elbows on your chest. Sometimes, you may be able to use a wall for support.

The Story and Impact

Once you have begun to understand the different lighting and composition principles outlined earlier in this chapter, you can think about how those principles can be used to better express your message and tell readers and consumers why it is important.

One useful tool for preplanning a photo shoot, or for editing pictures once they've been downloaded onto your computer, is *The Washington Post* hierarchy, developed by the paper's former assistant

Figure 7-7: The best photographs go beyond mere information or graphic appeal; they make the viewer feel as if he or she is experiencing the moment. The Vietnamese baby has a birth defect caused by the defoliant Agent Orange. (Photo courtesy Steve Raymer)

managing editor for photography, Joe Elbert. The *Post* hierarchy has four levels, in ascending order of importance.

1. Informational—A "just the facts, m'am" approach that tells a viewer a basic "who, what, when, where, why" about the situation.

2. Graphically appealing—Photographs that make strong use of the composition principles discussed earlier in the chapter and that, in many cases, apply those principles in ways that add interest to what could be a dull photograph. For example, a photographer covering a graduation might choose to compose a wide-angle shot of the virtual sea of colorful hats being worn by the graduates.

3. Emotional—Better photographs make the viewer feel something, whether anger, sadness, joy, or something else. Shooting photos with emotional impact requires patience and empathy with those who are being photographed.

> The best photographs move those seeing the photograph into the role of participant instead of passive viewer. These pictures make us feel as if we're reliving the moment captured in the frame.

4. Intimate—The best photographs move those seeing the photograph into the role of participant instead of passive viewer. These pictures make us feel as if we're reliving the moment captured in the frame.[1]

"Intimacy can be achieved in several ways—by getting physically close to our photographic subjects and by empathizing with them, trying to put ourselves into the moment and into the life of the person or persons in front of our lens," says Raymer, who has two decades of experience at *National Geographic* magazine and is now a professor at Indiana University. Raymer's photo in Figure 7-7 demonstrates how intimacy is achieved within the frame. "Many photographers, however, confuse intimacy with merely shoving a camera with a wide-angle lens into someone's face. Photographic intimacy involves understanding and empathizing with the subjects of our pictures so that we can reveal what most people would miss—or never see."

The *Post* hierarchy can be used in a number of ways. One way to think of it as a goal for shooting, to come back with as few strictly informational photos as possible and more in the three higher categories. Another approach is to try and have your photos exemplify at least two of the four categories. So, at minimum, your photos should be informational and graphically appealing. Better photos would also evoke emotion, and the best pictures would have the rare combination of all four categories.

Shoot a Variety

Even if you know that only one shot will eventually be used, approach each assignment as if multiple photographs will be needed. You'll give your colleagues more possibilities to work from, and you'll have a better chance at capturing the ideal shot. To that end, take photographs from a variety of views and from a variety of angles.

A useful way to think this through is to dig back a bit in history. *Life* was one of the most successful magazines ever, captivating millions of Americans in the middle of the 20th century with its use of documentary photography, particularly its multiple-photo

1. Kenneth Kobre and Betsy Brill, *Photojournalism: The Professionals' Approach* (Boston: Focal Press, 2000), 196-198.

Figure 7-8: Different perspectives can help tell stories in new ways. By shooting from the upper reaches of the Istiqlal Mosque in Jakarta, this photographer emphasizes vastness. (Photo courtesy Steve Raymer)

stories. *Life* photographers focused on eight types of shots to ensure they covered multiple angles of a story and had a strong variety of pictures for the final publication:

- Overall—A wide-angle shot that emphasizes place or the scope of the scene.
- Medium—Captures one activity or group.
- Close-up—A detail shot of one specific item.
- Portrait—Often a person in his or her natural setting, known as an environmental portrait.
- Interaction—People engaged in conversation or an activity.
- Signature—Captures all the key elements of the story and summarizes the story.
- Sequence—Closely related photos with a clear beginning, middle, and end, or a before, during, and after.
- Clincher—A photo to end the story that wraps up what we've seen previously.[2]

Someimes, simply changing the height of the camera can create a very different effect. Climbing a few feet higher on a set of steps

2. Kobre and Brill, *Photojournalism*, 146-147.

can give the photographer more of a look at the entire scene, while getting low and shooting up at the subject gives an entirely different perspective. In Figure 7-8, notice how the photographer's decision to get above the crowd helps create a sense of vastness.

"The Decisive Moment"

The more you practice mastering the above rules, the more they will become second nature, and the more you can focus on capturing what famous photographer Henri Cartier-Bresson called the "decisive moment," the instant where preparation meets opportunity and results in a memorable image that has resonance for generations.

"There is a creative fraction of a second when you are taking a picture," Cartier-Bresson told *The Washington Post* in 1957. "Your eye must see a composition or an expression that life itself offers you, and you must know with intuition when to click the camera. There is no trick. No one can tell you that. You have to know. That is the moment the photographer is creative. Oop! The moment! Once you miss it, it is gone forever."

Celebrity photographer Ron Galella in a 2008 interview with *Macleans* magazine compared his work of spontaneous and unauthorized photos to celebrity photographers who do studio shots.

"I like mine better," Galella says. "Not technically, theirs are better technically in terms of lighting and so on, but mine capture the fleeting expression you get when stars are themselves. You see, stars are usually acting. But I get them in their environment, when they're not acting, they're themselves. I don't want them looking in my camera, I want them doing something, talking to each other, being themselves. That's what I capture, their realistic expressions rather than poses." Galella's work is also featured in the law and ethics chapters in this book.

So, follow the composition principles above, be persistent, and anticipate. Your photos will be better for it.

CHAPTER QUESTIONS

1. What are some ways photographers can emphasize elements within the frame? How do these relate to visual principles you read about in previous chapters?

2. What are the best times for shooting photographs outdoors? What are some techniques you can use if you're shooting in less-than-ideal lighting conditions?

3. Imagine you are assigned to photograph your school's graduation ceremony. Using the *Life* formula as a guide, brainstorm the different types of shots you could get in order to ensure multiple aspects of the story are represented and that there will be a wide variety of pictures to choose from.

4. Grab a copy of a popular magazine. Examine each photograph and evaluate how many qualities of *The Washington Post* hierarchy it exhibits. How many have more than two of the four characteristics? Do any exhibit all four characteristics?

8 Composition for Video

The World Wide Web became a medium for the masses in the mid-1990s, but for the next decade, users found it very difficult to share video. Slow, dial-up modem connection speeds, relatively sluggish computer processors, and the lack of uniform standards for compressing the huge amount of data contained in a video file made Web video a frustrating affair for producers and consumers alike.

By the mid-point of the new century, the technological obstacles were falling by the wayside. A larger percentage of Internet users were connected to high-speed networks that could accommodate high-bandwidth video content, and MPEG-4 compression had become the industry standard for delivering streaming video through the Internet to personal computers. In 2004, there were an estimated 14 billion views of Web video, a number that would grow exponentially larger in subsequent years thanks in large part to the success of YouTube, a site that boasted 65,000 new uploaded videos a day in 2006. While you were reading this paragraph, users added another 24 hours worth of video to the YouTube site, according to one estimate.

Sites like YouTube and increasingly portable production technologies have leveled the playing field for creating videos and distributing them. No longer does one need thousands of dollars worth of equipment or expensive studios to create compelling video. Yet, the thousands of videos being uploaded each moment means that it is increasingly difficult to get viewers to pay attention to your creation over all the others. If you want someone to see your video, you have to rise above the noise. Content is key—a compelling message, thorough research, and strong writing—but beginning videographers also need to keep

KEY TERMS

aspect ratios

close up shot

headroom

leadroom

long shot

medium shot

180-degree rule

pan

three-point lighting

tilt

in mind video composition principles that have stood the test of time. Many of these principles have been introduced in previous chapters and have specific applications to video.

Headroom and Leadroom

You have already learned about the rule of thirds in the visual theory and photo composition chapters. Dividing the frame into three equal segments horizontally, and another three equal segments vertically, is an easy way to avoid some common mistakes beginning videographers make. As demonstrated in Figures 8-1 and 8-2, placing the eyes of your primary subject on the top horizontal line ensures that you have properly achieved what video professionals call headroom. Placing the eyes above the line puts the subject's head too close to the top of the frame, and putting the eyes in the vertical center leaves wasted space that will be simply distracting to those viewing the final product. Another way to think of this for medium-range shots is that one third of the frame is for the area above the eyes, the middle third is for the face and shoulder, and the lower third is for the torso.

Figure 8-1: With the subject's eyes in the vertical center of the frame, there is too much room between the head and the top of the frame.

Figure 8-2: Aligning the eyes near the top horizontal third allows for appropriate headroom.

In a similar manner, you can use the rule of thirds to ensure that there is enough space between the end of the subject's nose and the end of the frame—a concept professionals refer to as leadroom or talking room. A shot without proper leadroom leads to dissonance in the viewer, a sense that the subject is trapped within the frame. Leaving some space in the same direction the subject is looking toward gives viewers the visual cue that the subject is interacting with something else that is just outside the frame or is moving in that direction. Another way to remember this is to imagine that the person is a charac-

Figure 8-3: The shot at left demonstrates improper leadroom, as the subject is too close to the edge of the frame. In the shot at right, the subject is aligned along the intersection of the middle and right thirds, allowing appropriate leadroom.

ter in a newspaper cartoon—there has to be room for her words to fit within the frame. Figure 8-3 demonstrates the concept of lead-room and how you can apply the rule of thirds to use it properly.

Creating a Sense of Depth

Although the 2009 movie *Avatar* demonstrated the potential for three-dimensional film beyond children's movies, in the short term, the vast majority of video production is still created for delivery on flat, two-dimensional computer monitors or television screens. Videographers can use composition techniques, however, to suggest to viewers' brains that depth is actually there. As one example, those shooting interviews are always cognizant of the two-eye rule, which means that both eyes of the subject should always be visible in the frame. The two-eye rule forces the subject into an angle, which keeps the subject's profile from appearing flat.

Another technique is to include objects in the foreground or background to your subject to simulate depth. For

Figure 8-4: The composition of this shot includes elements in the near foreground, middle distance, and long distance to give a sense of depth. (Courtesy J. McMerty)

example, the composition of this beach shot in Figure 8-4 includes a chair in the near foreground, waves and ocean in the near distance, and the sky in the far background.

Screen Direction and the 180-Degree Rule

While shooting, you have to always keep in mind that you'll be piecing together dozens, if not more, shots during the editing process, and those shots will have to make coherent sense to your audience. Many beginning videographers forget this concept when it comes to screen direction, the way subjects are facing on screen.

Imagine you're shooting video of a man and a woman having an argument, and that you initially set up your camera just behind the right shoulder of the woman, with the man facing screen left. Now, imagine you want to try a slightly different composition. If you move the camera just a few feet to a position behind the woman's other shoulder, the man is now facing screen right. If you try to marry these two pieces of video together in the editing process, your viewers will wonder how the man managed to flip positions on the screen. To avoid this problem, many experienced videographers invoke the 180-degree rule by imagining the subjects are standing (or sitting) on a giant circle and keeping the camera on the same half of the circle throughout the shoot. More simply, once you establish a subject's screen direction, left or right, maintain that direction throughout that shot or series of shots. When you block your scenes in a narrative film you want to keep this rule in mind. If you don't follow this rule it can become quite confusing in chase scenes, for example, where it appears that the actors are about to run into each other rather than one chasing the other.

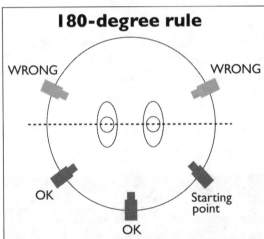

Figure 8-5: The 180-degree rule helps maintain correct screen direction.

Planning and the Essential Shots

Before you go out on assignment, take a few minutes to think about all the material you will need to capture. Experienced videographers say it takes a minimum of twenty minutes of source video to be able to create an edited three-to-five-minute production. And with rare exceptions, audiences aren't interested in twenty-second static shots. It's better to think in terms of four-to-five second segments that work together in sequences to tell a larger story. For those twelve or so shots your viewers will see each minute, you want to think variety, not only for the sake of interest but so that you're also presenting your message from multiple points of view.

Videography comes down to three basic shots. Although each of these shots has numerous variations, mastering the three basics will put you well on your way to creating top-notch video packages.

Long Shot: These generally are used to establish context, the bigger picture surrounding the message you're creating. In Figure 8-6, the viewer is introduced to the environment where the two people live. This use of a long shot often is known as an establishing shot, since it many times signifies the place in which the story is taking. Long shots have a large amount of visual data that a viewer cannot

Figure 8-6: This long shot establishes location and a sense of place. (Courtesy J. McMerty)

Figure 8-7: The medium shot is often used in television news. This over-the-shoulder look gives the viewer the sense he or she was present when the discussion took place. (Courtesy Matthew Dawson)

interpret instantly, so in the final edit they are generally held on the screen for a longer period of time than are closer shots.

Medium Shot: These are the most-often used shots in television and cinema production, as they allow the viewer to get a good look at a subject but are not as intrusive as a close-up shot. When focusing on people, the medium shot often includes the head, shoulders and part of the torso. This shot also easily accommodates two people together, known by professionals as a 2-shot. In Figure 8-7 above, the composed medium shot focuses primarily on the person facing the camera, but it also captures enough of the interviewer so the viewer understands this is a question-and-answer session. Well done, this type of shot can make the viewer feel like a participant in the discussion.

Close Up: These add intense detail about the subject matter. They can be of a person's face, emphasizing emotion or identifying features. Figure 8-8 on the following page comes from the same shoot as the previous example. This close up lets us focus on the subject's facial features and his earnest look.

Figure 8-8: This close up, from the same shoot as the previous example, allows the viewer to focus on the identifying features of the person being interviewed. (Courtesy Matthew Dawson)

Close ups can also bring the viewer more intimately into the subject's world. For a moment, imagine you are shooting a story on your school's star basketball player. A videographer could shoot a close up of the player's face as he yells encouragement to his teammates while resting in the bench. Or, another close up could focus on the player's hands as he palms the basketball during warmups. In the editing process, such shots are often used as cutaways or inserts, as they make for useful transitions between two medium shots. Students doing their first projects often do not get close enough to shoot those strong, compelling close ups that will draw the viewer in. So as you are shooting, make sure you get close.

Some professionals suggest a typical video production has approximately 50 percent medium shots, 25 percent long shots and 25 percent close ups. It would be a mistake to hold your work to strict mathematical formulas, but keeping those proportions in the back of your mind will get you into the habit of thinking in sequences and ensuring you have sufficient coverage for all the different types of shots you'll need.

You'll also want to keep in mind the final format in which your production will be viewed. Long shots tend not to work well if the target size is for delivery on a smartphone or computers with slow Internet connections—there simply isn't enough room on smaller screens to pick up all the detail. Likewise, traditional television has tended to be a medium for close-up and medium shots. Of course, full-blown Hollywood cinematic productions can make full use of long shots.

Aspect Ratios—16:9 vs. 4:3

Framing shots in an aesthetically pleasing way has always been a challenge for videographers, but that task has been complicated in recent years by the advent of high-definition television, which is bringing about a change in the dimensions of the image. In video, aspect ratio refers to the relationship between the width of the frame and its height. Since the era of silent film, the predominant aspect ratio has been 4:3, resulting in a rectangular frame that is slightly wider than it is tall.

Although Hollywood cinema productions had turned to more widescreen formats beginning in the 1950s, television remained a 4:3 medium until recently, when HDTVs became commonplace in American households. The high-definition format has a 16:9 aspect

Figure 8-9: This shot was originally composed for a 16:9 format, but if it were to run in 4:3, one would need to crop from the left side of the frame to the white line. (Courtesy Steve Raymer)

ratio, which results in a much wider frame, in relation to its height, than its 4:3 counterpart.

Figure 8-9 illustrates the differences between the two aspect rations. The full frame is at 16:9—if the viewer has a standard-definition television, however, or if a client needs the video to play on the Web in a standard 4:3 format (say, 640 by 480 pixels), a significant portion of the image will need to be cropped in order for it to work.

In some cases, widescreen Holllywood productions have been converted to the 4:3 format by letterboxing, which puts black bars at the top and bottom of the frame, creating in essence a 16:9 frame within a standard-definition screen so the film can run in its intended aspect ratio.

Beginning videographers should get familiar with shooting in 16:9 because it will soon be the standard for all of their projects. The wider frame dimensions give you exciting possibilities for composition that are not possible with the 4:3 ratio. Be aware though that you are in a transition period technically, and that you may still have projects that require the final output to be 4:3. Know your audience or talk to your clients before going out on a shoot.

Hold Your Shots

Although the final production will consist of a series of brief shots, you will want to shoot a bit longer than you anticipate using to ensure that you have plenty of material to choose from and that you don't miss something important. You'll find that you think you are holding shots for longer than you actually are. So it probably best to count in your head (not out loud because clearly that will interfere with your natural or interview sound). A good practice is to compose the shot, record for at least fifteen seconds, then continue recording for five more seconds before ending the shot or moving the camera to a new position. If someone will be speaking during the shot, you should also record for five seconds before the person begins talking, to ensure you capture all of the sound.

Moving the Camera—Pans and Tilts

In general, you want to leave your video camera still and let action move into and out of the frame. On rare occasions, subtle camera movement can be

The key is to make sure that pans and tilts are motivated by content. Don't just move to be moving.

used for emphasis. A pan is a slow, steady move of the camera from one side to another that is often used to emphasize how long something is, such as a line of people waiting in the early morning hours to get into a department store for a day-after-Thanksgiving sale. A tilt is a slow, steady movement up-or-down movement of the camera that usually emphasizes how tall something is, such as a skyscraper. These two shots should always be made using a tripod for more careful control of the movement. And be sure not to move too fast—pans and tilts unfold much more quickly on screen than you often realize while making the shots. If you decide to try a pan or tilt, be sure to keep the camera still for five seconds before the movement and five seconds after the movement so you'll have some space to trim when it comes to the editing process. The key is to make sure that these moves are motivated by content. Don't just move to be moving. On the other hand, after you've gotten all the shots that you know you need, try pans and tilts and see how you like them.

All video cameras have a zoom function that allows you to gain a wide-angle view or a close-in view without physically moving. You should consider the zoom as a tool that in some instances can help you compose a shot. Do not use zoom as an "effect" to be included in your edited production—with rare exceptions, on-screen zooms are a sure sign that an amateur is at work. Be particularly wary of the digital zoom option, which usually makes the resulting video blurry and jumpy. Most professionals disable digital zoom. Also, keep in mind that when you zoom all the way in, the camera will pick up the slightest movements. So if you must shoot without a tripod, make sure that you zoom out wide before shooting. And try to find something to steady the camera, be it a nearby desk or chair, or steady the camera by holding your elbows in against your body.

> Do not use zoom as an "effect" to be included in your edited production—with rare exceptions, on-screen zooms are a sure sign that an amateur is at work.

Pay Attention to the Light

Many of the lighting principles you read about in the still photography chapter also apply to shooting video. You want to avoid shooting in the middle of the day when possible and instead try to schedule your work for the early morning or early evening hours when the sun creates subtle shadows and pleasing light. Shoot with the sun behind you and to one side. If you must shoot when the sun is high,

one trick professionals use is to hold a hand or a piece of cardboard over the top edge of the lens so that the camera doesn't overestimate the amount of light.

Shooting video indoors can be quite problematic. Many offices and places of business use fluorescent overhead lighting, which often gives subjects an unappealing green skintone on video. Ideally, you would have access to a basic light kit, which allows videographers to create more ideal lighting conditions. Your best and most common setup is three-point lighting, which consists of 1) a key light, the main source of light that is placed in front of the subject and slightly to one side; 2) a fill light, which eliminates shadows created by the key light by its placement on the other side of the subject; and 3) a back light that sits directly opposite of the fill light and serves to "lift" the subject off the background a bit, creating depth. Figure 8-10 at right shows how the basic setup works.

Figure 8-10: Three-point lighting is a basic and effective strategy.

Even if you don't have a light kit, you can use the principles behind three-point lighting. If you only have one light and need to shoot inside, you can use the one light and bounce it off a white ceiling to bathe the room in light. Another technique during the daytime is to place a subject six feet or so away from a window, then have someone hold a piece of poster board or a reflective car sun visor opposite the window in order to bounce the sunlight back onto the subject and reduce the shadows.

Story First

No matter what type of camera you use, or whether you're shooting for a Web audience or one viewing your production in an IMAX theater, always remind yourself that all your decisions should be content driven. As a novice videographer, you likely are eager to experiment with unusual camera angles or movement, and such experimentation can be good learning experiences. But when doing so, put the audience foremost in your mind and ask whether your techniques will help the viewer gain a greater understanding, or whether it will simply be a distraction that pulls her away from the greater effect you are trying to create with your production.

CHAPTER QUESTIONS

1. Take your video camera to a local event. Find an interesting scene and shoot it for 20 seconds in 16:9. Switch to 4:3 and shoot for another 20 seconds. Compare the two. What's different?

2. Record your favorite television show. Log a five-minute segment, noting the types of shots you see (long, medium, close up).

3. What are appropriate uses for pans, tilts, and zooms?

9 Sound

When was the last time that you began driving your car, prepared to study, went for a walk or run, or decided to relax for a while and left sound out of the equation? For most of us, the answer would be, "It's been a while." Even if you can remember doing one of these without involving sound, it's a good bet that sound from recorded music on your MP3 player, a television, a radio, or a combination of sound forms coming from your computer fills more of your life than you realize.

Sound is an essential component of the digital media landscape, and it's the foundational element in many visual presentations, too. If you are working to produce a television news package, for example, the audio track is what's laid down first, according to Teresa Keller in her book *Television News*, something that most people don't realize. Narration and natural sounds are the foundation of television news reports and are just as important as the visual.

When you begin to think of sound as an element of design, though, you probably think immediately of music. Recorded music and the ability to share sound via recordings or broadcast media are an integral part of our lives. In 1919, for example Americans bought nearly 107 million records. In 2009, Americans purchased an incredible 1.545 billion pieces of music in albums, digital tracks, and video format. Of that total, 1.16 billion sales came in Internet downloads.[1] It really is impossible not to have sound as a part of your life un-

KEY TERMS

analog

cardioid

Digital Millennium Copyright Act

encoding

fades

lossless file

MP3

omnidirectional

segue

sound bites

1. David A. Copeland, *The Media's Role in Defining the Nation: The Active Voice* (New York: Peter Lang, 2010), 161; "2009 Wrap-Up: Music Purchases Up, Album Sales Down," *Rolling Stone Rock & Roll Daily*, January 7, 2010, http://www.rollingstone.com/rockdaily/index.php/2010/01/07/2009-wrap-up-music-purchases-up-album-sales-down/.

less you only use print media or if you are hearing impaired. In print, of course, you'll read about recordings and the artists who make them. Sound, then, is an absolutely critical element of life, and to paraphrase inventor Nathan Stubblefield from 1902, his medium—radio—was capable of being "everywhere."[2] Recorded music in the twenty-first century is everywhere. It is— or should be in many instances—a critical component of digital media design.

When you think of sound for use as a digital designer, though, you should not think solely of music. Sound is essential to the work of communication specialists in a number of ways. Natural sounds—like people walking down the street, sirens screaming warnings, or bombs bursting in the distance—made the work of Edward R. Murrow come alive during World War II as he broadcast nightly with his *This Is London* radio telecasts for CBS. Sound remains essential to the radio, television, and Internet experience, especially in news stories but also in any type of programming or site where sound can capture the attention of the audience and set the stage for what will follow.

> Today, a sound bite lasts around eight seconds, and the people who are interviewed by media are becoming quite adept at developing a quick, information-packed statement that will be used by media.

The spoken word is essential, also, to the sound component of digital design. Stories, often told by the principal players, are the backbone of journalism. Think about the common attribution used in print journalism, the word "said." Then, think about how much you can learn by hearing people say something with the inflection in their voice. That's one of the elements of sound that written words often cannot connote.

Long narration, especially with Web sites and even with most news programs both online and broadcast, is not the way words are most frequently used. Instead, sound bites are the principal means of supplying information. A sound bite, a small element of a larger statement by someone, has been a means of sharing information in media since the huge rise of television news at the end of the 1940s. Sound bites used to be incredibly long in comparison to today. They averaged around forty-five seconds in the 1960s. Today, though, a sound bite lasts around eight seconds, and the people who are interviewed by media

2. Nathan B. Stubblefield, *St. Louis Post-Dispatch*, January 10, 1902.

are becoming quite adept at developing a quick, information-packed statement that will be used by media. Martin Luther King in the 1960s learned to speak in a way that powerful sound bites could be extracted from his speeches. Bill Clinton, when he challenged and then defeated George H. W. Bush in the 1992 presidential election, repeated his sound bite whenever he could. "It's the economy, stupid" was all that Clinton needed to say in reference to the nation's recession to strike a sympathetic chord with the American public.

Sound and the Computer

In order to use sound in your media creations and projects, you either have to capture it or find a pre-recorded sound source. Capturing sound means that you use a microphone and record. A microphone will pick up any sound that reaches it, so it is important to take precautions in the recording process not to have unwanted sound recorded. Exactly how you do this, though, is something that is specific to your method of capturing audio. If you are in a classroom your instructor can explain the techniques to you.

Music or any sound that is distributed over the Internet or used in a software program on your computer must be in a digital format. If you record that sound directly to a computer, then the sound has already been digitized. If you use another means of recording, say a tape player, then you must convert your recording from its analog format to a digital one.

Analog, which comes from the word analogous and means a replication of the original, used to be the way all audio and even video was recorded. For an analog recording to be digitized, it must be converted into a measurement that computers can understand. That means that it is converted into numbers. Sound is created in a wave form, and this wavelength—in its ideal form—creates a sine wave. The image at right represents a sine wave. As the sound moves away in either direction from the center line, which is silence, it creates sound, and the farther from the center line, the louder the sound. The sine wave is a perfect form of sound because its waves are equal on either side of silence.

Figure 9-1: A sine wave

As you create audio, video, or Web projects, you won't care about sine waves or about the difference in analog and digital, but your computer will. It uses its soundboard and an analog-to-digital converter to change the original sound to a digital one. The computer assigns a numerical value to increments above and below the center silence line of the sound. That sound, be it music, a voice, or a jet plane engine will always be able to be replicated identically once it has been digitized. The sound will never degrade, something that used to happen to analog sound recordings. Tape and vinyl records can lose some of their sound properties because continued use often consumes part of the material onto which the sound has been imbedded.

Just because you digitize a sound, though, doesn't mean that it will sound good. First, your sound can only be as good as the original. It is true that computer programs and some recording equipment allow users to "clean up" some "noise" from a recording. The alternating current of electricity, for example, creates a sound that is often called the sixty-cycle hum. It can be removed from a recording by eliminating the frequencies that create the sound, and that will make your sound better. But, the frequencies that you eliminated to remove the hum are also erased from the sound you want to keep. That means that in the process of removing unwanted sound that you also remove a part of the sound you want listeners to hear.

> The greater the bit rate, the larger the file. The larger the file, the longer it takes to upload. The longer it takes to upload, the more impatient most people get with a Web site.

Next, how you sample sound for digitization affects the result. Because digital sound is numeric, the more numbers you assign to the distance above and below the silence line, the more accurate the digital sound will be in relation to the original. Assigning a specific number to measure the wave above and below the base sound line is called encoding. If your sound wave is assigned three numeric spaces—called bits—by the computer to cover the wave above the line and three below, then you have three-bit encoding. Encoding has generally already occurred with sound files and with images that you will use. The computer and software automatically take care of that through a series of digital audio file options.

Encoding the number of bits in a digital recording seems as if it should be a no-brainer. If a sound is more accurate when it is represented by a greater bit rate and we want the sound in

our presentations to be the best that it can be, then we would as-
sume that we would encode the digital sound with more numbers
to produce a better sounding and more accurate sample of the orig-
inal sound. Therein lies the problem for the use of sound on the
Web. The greater the bit rate, the larger the file. The larger the file,
the longer it takes to upload. The longer it takes to upload, the more
impatient most people get with a Web site. The same dilemma faced
owners of the first generation of Blu-ray players. The new digital
format offered the possibility of much more information on a disc.
The problem was that uploading all this information meant that the
time between placing a disc in the player and actually being able to
watch something seemed like a lifetime compared with the upload
time for the traditional digital video disc.

Because we want the best sound possible that takes up the least
amount of space and consequently loads the fastest, computer pro-
grammers and technicians have created specific types of digital sound
files. The most popular, of course, are
the MP3 and MP4, their names tak-
en from their creators and their spe-
cific version—Moving Pictures Expert
Group audio layer three or layer four.
Even though there are a number of oth-

> Even though there are a number
> of other digital formats for audio,
> MP3 has become the de-facto
> term that almost everyone uses
> to refer to digitized audio files.

er digital formats for audio, MP3 has become the de-facto term that
almost everyone uses to refer to digitized audio files. The general
population rarely refers to other digital file formats by their abbrevi-
ations—AAC (advance audio coding), AU (audio), WAV (waveform
audio file format), AIFF (audio interchange file format), MIDI (mu-
sical instrument digital interface), and numerous others.

MP3s, which were developed in the late 1980s and early 1990s,
are essential to music and general sound use in the online world be-
cause they take up less space than a similar music file recorded for
use solely on a compact disc or DVD. Just as jpegs (the name taken
from their creators, the Joint Photographic Experts Group) and gifs
(graphics interchange format) were developed so that images would
require less space and upload quicker in the online digital world,
MP3s do the same with sound. The original file is compressed by re-
moving some of the data in the music, which means that the sounds
at certain frequencies are removed. The resulting music file contains
enough frequencies so that those that have been deleted are either
imagined by the hearer or are not greatly noticed by their absence.
A comparison of a lossless file and an MP3 file—which is some-

times called a "lossy" file—of the same music is noticeable to some listeners who hear the files played on identical equipment. However, MP3s produce great sound in an extremely small amount of space, which makes them the ideal means of adding sound files to digital creations.

As you have no doubt already discovered, working with digital files allows you to break the time continuum with little problem. This means that you don't have to use a sound recording in the exact way that it was recorded. Digital sound files, as well as digital video files, allow you to work in the nonlinear world. A portion of any sound can be extracted and placed wherever you want in your creation. It is a natural process that the computer makes possible. Just as you might cut and paste text in a Word document, you can do the same easily with any piece of sound that you have captured and saved in digital form.

The only way to achieve this kind of editing in the pre-computer era would have been to take what you had written or recorded, cut it into strips that contained a single sentence or paragraph or measure of music and then restructured what you had written or recorded. You could, for example, place the first paragraph that you wrote as the third one. The eighth could have become the first. Or, in music, the tape that was used to record the sound could be cut and spliced to rearrange the music passages. The ability to do this without damaging your original creation is exactly what nonlinear editing with digital material allows. The original sound file is not damaged when you copy a portion of it and move it to any location in your project. All of your original files are safely stored. They are not destroyed in the editing process, and the digital copy sounds the same every time you copy it.

Should a Web Site Automatically Play Sound?

One of the great elements that sound provides for your online creations is the element of interactivity, which means that the use of your Web site is no longer a passive experience. Because you provide options for viewers, they may click to hear the screaming of monkeys from Costa Rica, a speech on any subject, or anything that has been recorded that will enhance the experience of your site.

While sound is essential to many media forms and can greatly enhance the online experience, its use is not always advisable as a default occurrence Web pages..

There is a caveat with sound on the Web though. While sound is essential to many media forms and can greatly enhance the on-line experience, its use is not always advisable as a default occurrence on Web pages. People may be looking at your Web site in a situation where sound is problematic. The sound volume on the computer might be cranked up so that when the site appears in the browser, what is heard is quite loud. Another problem might be that if the sound is music, and the type of music is one that the viewer really does not like, people may quickly exit your site. Also, since many people who use the Internet listen to their own choice of music while looking at sites, your automatic sounds could interfere with preferred listening of the users of your site.

Because adding sound to a Web page is really not difficult and people who are just getting into the art of Web creation often love to use every "bell and whistle" at their disposal, often sounds begin with the appearance of the page. For legal purposes, people sometimes only use a small amount of a piece of music, for example, and then loop it—repeat the sounds continuously. Hearing the same sounds over and over really is not the best way to maintain interest. And, as discussed earlier, the size of a sound file can affect the load time of a Web site. People looking for sounds will be more patient as large files load because they are waiting to hear something that interests them.

> Sound on Web sites should be available if the viewer wishes to hear those sounds, not forced onto them.

Sound on Web sites should be available if the viewer wishes to hear those sounds, not forced onto them. If you want sounds to accompany your site, make sure there is a way to silence them easily and quickly. Better, make turning on sound optional, something the viewers may choose to do as they look at your site. There is a tremendous difference in having sounds over which a Web site user has no control to sounds that users intentionally select for listening.

What Can You Use?

The World Wide Web allows access to literally millions of pieces of information, but as the law chapter explains, they are not all free for you to use without payment or permission. As you know, there are more Internet sites available than can be recalled in your memory that have pirated copyrighted creations. Sound, specifically recorded music, is the element that is almost always involved in

copyright litigation. Because MP3s are so easy to make and upload, people constantly use copyrighted music to accompany online elements that they create, especially video elements that are uploaded to sites like YouTube.

Most of the news surrounding sound and copyright has worked in reverse of the uploading of copyrighted material; it's centered on illegal downloads of music. The digital online world gained copyright protection in 1998 with the passage of the Digital Millennium Copyright Act. The act was designed to keep consumers from creating copies of copyrighted works with videocassette recorders and digital video disc players.

> By the end of the first decade of the twenty-first century, nearly 1.2 billion pieces of music were being downloaded legally from the Internet, principally via iTunes.

But the DMCA did not do much to stop the sharing of copyrighted music. File sharing software on the Internet quickly and easily would let someone in Spokane, Washington, for example, share all of her music files with someone in Savannah, Georgia, even though neither knew nor cared to know the person from whom free music was being obtained. The Recording Industry Association of America pushed for legal action to make MP3 recording technology illegal, but a federal court in 1999 ruled in *RIAA v. Diamond Multimedia Systems* that outlawing the technology that allowed the creation of MP3s—even if the source was copyrighted—was too broad because there were legitimate uses of the MP3-creating technology, too. This is the same legal reasoning the court used to allow VCR technology, relying on the fact that there were legal uses of the new technology.

The issue of music sharing came to a head in 2000 with an online file-sharing site called Napster. Created in 1999 by Northeastern University student Shawn Fanning, Napster had an estimated 70 million users when RIAA sued for copyright infringement. Heavy metal musicians Metallica followed with another copyright infringement suit. A U.S. District Court ruled that Napster's file-sharing software violated the fair use of copyrighted material. Though Fanning tried to broker a deal with the record labels to pay them in exchange for a licensing deal of their music, they declined.

Napster, though, wasn't shut down completely because some of the music that was being shared had no copyright protection or had permission to be shared by the copyright holders. In 2002, Bertelsmann AG, owner of BMG Music, bought the service for $8 million. Armed with legal decisions supporting its actions, RIAA began go-

ing after individuals for illegal downloads, threatening to sue for up to $150,000 per illegally downloaded copyrighted piece of music. In the midst of the Napster and illegal download controversy, Apple introduced iTunes, after its CEO, Steve Jobs, brokered a deal with nearly all record companies. As already mentioned, by the end of the first decade of the twenty-first century, nearly 1.2 billion pieces of music were being downloaded legally from the Internet, principally via iTunes. This in essence, solved many of the music piracy issues for people who wanted to own and listen to digital music but did not address that myriad of potentially illegal ways that consumers use the music in fan videos, school projects on Web sites, and share it through social media.

Music is a key part of content shared on social networking sites. Because it is so simple to add MP3 music to what people create, and they have songs that they like or that fit perfectly with the images in their creations, they simply add those songs without thinking about whether their use is legal. Making something purely for use in a classroom—for educational purposes—will not generally get people into trouble. But, in a world where social media and the sharing of everything via Twitter, Facebook, and YouTube is so common, people tend to share almost everything that they create. That is where you have to be careful with the use of copyrighted music.

In 2008, Stephanie Lenz created a video of her 13-month-old son gyrating and pushing a toy shopping cart to the music of Prince. The performer and the owner of the copyright of "Let's Go Crazy" threatened YouTube with copyright infringement. YouTube simply pulled Lenz' video. The mom, however, fought back, declaring that what she'd done was simply a fair use of the song, not a fair use violation. Federal courts are looking as if they will support Lenz' contention.

If Lenz wins her challenge, many things might change in terms of the use of copyrighted material. What probably won't change, though, is a fear among corporations and the people for whom you will one

Figure 9-2: This YouTube video of a 13-month-old boy dancing to a Prince song has sparked legal action concerning Fair Use under copyright laws.

day work to err on the side of caution. If any chance exists that they, or you as their employee, could be sued for a fair use violation, they will demand that you not use work that might raise fair use issues.

So, it makes sense even when creating projects for class—if you have any plans to use what you create in a way that would make it available to the public, like in an online résumé or portfolio—to use royalty-free sounds. There are a number of subscription-based services available, such as Killer Tracks, so see if your school has a service. If you look online, though, you can find dozens of sites that provide royalty-free music to use in your creations. Be careful that you read the terms of agreement for each site to make sure it is okay to use these in your creative work.

> You can find dozens of sites that provide royalty-free music to use in your creations. Be careful that you read the terms of agreement for each site to make sure it is okay to use these in your creative work.

One example of a site where you might find music is freemusicarchive.org. It offers music from fourteen different musical genres and in spoken form for free use. Free Music Archive in its terms of use explains that "The Free Music Archive is an online library of audio and video content that the public, including music fans, webcasters, and podcasters, may listen to, download, or stream for free." But, the terms of use for the site's content also explains that each piece that's been uploaded may have slightly different arrangements for usage. Here's a typical example: "You are free to stream, download, copy, store and burn this work as reasonably necessary for your personal, noncommercial use. You may not alter, perform, adapt or otherwise redistribute the work under any conditions."

Another free-music site, PacDV free sound effects, simply states this as its terms of use: "These music tracks are not in the public domain but you may use these tracks free of charge in your video, film, audio and multimedia productions. All we ask is that you link back to our site or mention 'Music by www.pacdv.com/sounds/' in your credits. You're not allowed to re-sell these tracks, post on a Web site for download, or link directly to the individual tracks."

So, while you may know copyrighted material that you think would work perfectly in your production, a little bit of exploration will no doubt lead you to some great, royalty-free music or sound effects that you can use on Web pages, in advertisements, in videos, or in films that you might create.

Music for Videos and Film

Most of the video or film production (narrative or documentary, including advertisements) that you will create that contains a music track will probably require only one piece or song. If you plan to use more than one song, they will rarely segue from one to another without a period of time when no music is required. Also, unless you plan to upload your creation to the Web, your video project will probably be saved on a hard drive and then burned to a CD-ROM or DVD. Other than the time it takes for the information to be saved, you will have fewer worries about the size of your music files if they are presented on one of these media forms instead of online. If you plan on creating a video to upload, then you'll have to remember upload times for your project.

> Music can immediately change the mood of a piece, so you have to be aware of tempo. Do you fade music in or out? Where do you cut music if it must be cut?

When you add music to accompany video, you need to remember a number of things. Music can immediately change the mood of a piece, so you have to be aware of tempo. Do you fade music in or out? Where do you cut music if it must be cut? Cutting on the downbeat of music or before accented sections is a good rule to follow, especially for instrumental music. Because music is written in phrases, it is sometimes easy—because you are working with digital copies and in a nonlinear way—to repeat key phrases to match your images or action or even to remove elements that seem repetitious for the same reason.

Repeating sounds or pieces of a song is called looping, and it is best accomplished by capturing a musical phrase just before it begins and looping it so that the music retains its tempo. If the music has four beats per measure, for example, you would want to preserve that feel with however many measures you loop whether that is only one or two or more. If you do plan to edit more than one piece of music together, then you have to be careful. Do the styles of music complement each other? Do they make sense in relation to what is happening visually? If you simply pull from the same piece of music, there are usually fewer problems than when multiple pieces are used. You want to make sure that the music track that you create does not create a disjointed soundtrack that immediately calls attention to your edits and disrupts the flow of your creation.[3]

3. Stanley R. Alten, *Audio in Media,* 8th ed. (Belmont, CA: Wadsworth, 2008), 404-407.

Another important part of sound in relation to visuals revolves around the sound transitions in your creation. According to Stanley Alten, author of *Audio in Media*, you may do this as a segue, a fade, or a crossfade.[4] A segue means that one piece of sound ends and another begins immediately without a break. This could happen if you had an image of someone driving a car that jumped immediately to a flower blowing in the wind or to a person sleeping. Doing this with images that are accompanied by sound would probably necessitate a radical change in the style or composition of the music.

4. Alten, *Audio in Media*, 408-409.

ANDREA HSU

A VIEW FROM THE PROFESSION

Andrea Hsu is a producer for National Public Radio's "All Things Considered"

Q: How does NPR take things and repurpose them for an online format or create things specifically for online?

Hsu: We also actually have some writers who do web-only content, so sometimes they're going to be doing some reporting and adding to the web stories. I think now our website's kind of a mix of things. You'll have the AP stories, and you'll have these stories that are generated by our writers, otur reporters, who report for NPR.org, solely; then you have the radio stories.

For the radio stories, since I work on the show, the things that we spend most of our time doing are the host interviews, and so if one of our hosts is interviewing, [like] Robert interviewed Peter Galbraith, who is the deputy U.N. social representative in Afghanistan. I think it led our second hour, and so we had my colleague who's right next to me on the web team. He listened to the interview, and then taking a little bit of information from the wires, he wrote basically some copy to go up on the web. I think it actually went up before the interview went up. Then we pulled a picture, I think it was probably a wire photo of Peter Galbraith. And meanwhile, I was working on the radio story that went with it and aired at 5 o'clock. So in that case that was online, and I think the transcript also goes up, so if you listen to the interview, the interview is strictly Robert who sort of introduces who Peter Galbraith is, and then it's a conversation between the two of them that went on for maybe four minutes.

The online story has a little bit more background, who Peter Galbraith was, what the U.N. mission was in Afghanistan, so there's a little bit more background information but less of the actual conversation. He sort of pulled out the key points, the highlights. Then below what we call the web text, the full transcript

Fades are used to enhance a change between dissimilar elements and to hide transition between scenes. To do this, sound may fade in or out. It is less dramatic than the segue, which abruptly cuts from one element to another. When you create a fade-in or fade-out, you should remember that the sound and the visual elements do not have to sync perfectly. The sound fade-in, for example, could begin slightly ahead of the visual change or vice versa—the sound of waves crashing on a beach being heard before the waves are actually seen. The fade-out of sound could continue even though the screen may have already gone to black—the waves disappearing while the sound of them continues. This is called an L cut because when you

will be there the next morning. So we figure that listeners who are in their cars, or at home listening to their radio, they're listening to conversation, whereas people who online are spending less time. And so the amount of information is condensed. There's more information in a way because there's more background to give it more context, but then the actual conversation that you would have heard online was much more in depth than the quotes that were pulled for the online story.

For the web, people want sort of more hard facts fast. So also, other types of stories I've seen, we might have a story on the radio that is very sound-rich, it's outside, it's maybe in a park, there's lots of sounds of nature, or it might be in a factory, and you hear the machines turning, but that's very hard to convey just in text, for our website. So let's say you're in a factory setting, and the radio piece will have all these different sounds. On the web version, you actually might have more statistics, because in the radio story, it's sometimes hard to list a lot of numbers. When you hear a lot of numbers, it starts to get confusing very quickly, but let's say in bullet points on the web, it can be very clear. So we work with our online team, sort of tailor the text that goes on the web, to fit the way people consume news.

Q: How is social media playing into all of this?

Hsu: We have a social media team, and they deal with the comments that people leave on NPR.org. They sort of run that; they also do Facebook, and Twitter. And reporters use this, too. Oh, I know. Our reporter in Beijing, Anthony Kuhn, was there a couple months back, and there was unrest in the northwest. I saw him a couple weeks ago, and I said, "Oh, how'd you first hear about that," because he got out there very quickly. I was sort of surprised that by afternoon our time, which was middle of night his time, he was already there. And he said, "Oh, I first saw it on Twitter." And so, he said, "Yeah, I follow up a bunch of Twitter feeds, and I saw that on Twitter and thought, oh this could be big." He just got on a plane and went, so I mean, it's pretty amazing that he was able to do that.

cut this on film with the audio track cut somewhat after or before the last frame of video, the cut pieces of the film resemble the shape of the letter L. Experimenting with fades will help you achieve the effect that you want.

A crossfade is similar to other fades, but it allows for a smoother sound transition because the sounds that are changing tend to blend together. As a result, there is no noticeable change in volume and no noticeable change in the pace of your production.

Sound for Radio

Radio is, of course, the medium of sound only. But radio is not solely a broadcast medium as it once was. Radio is beamed from satellites, and it is also streamed online. As a medium for presenting music, you will not be concerned to a great degree about how you put sound together. Radio simply delivers recorded music. If you think of creating items for radio, though, such as news reports or entertainment programs, you quickly realize that how you combine the spoken word with sounds allows the listener to visualize mentally what's being portrayed via sound alone. The auditory radio program does not differ that much from the sound elements you create for video except sound alone conveys all meaning to the audience.

Sound for radio, in this context, is really storytelling, which is the principal purpose of journalism. Travis Lusk, a former market digital media manager at CBS Radio, believes that great storytelling is the key to success. Combining narration with interviews, sound effects, and music creates a great story. Lusk suggests that you need look no further than to the late Walter Cronkite to understand the value of sound in storytelling.

> " (Radio) is intimate. It gives the impression that the message is coming from inside of yourself, therefore it can have great impact. But this can only be done if practitioners understand how to develop messages that speak to both the imagination and the intellect at the same time. "
>
> **FRANK STASIO**
> NATIONAL PUBLIC RADIO
> CORRESPONDENT

Cronkite, of course, was known for his work in television news, but before that, he worked in radio. "Play back any of his old television reports, but close your eyes," Lusk suggests. "Instead of watching, just listen. Then play it back with your eyes open. If the story you pictured in your mind with your eyes closed is close to what ends up being depicted in the video footage, Walter has done a great job." And, in almost all cases, Cronkite pulled off the story via the soundtrack. That is the goal when creating

sound for radio when the goal is more than playing recorded music or providing spontaneous talk.

Radio, according to long-time National Public Radio correspondent Frank Stasio, "is intimate. It gives the impression that the message is coming from inside of yourself, therefore it can have great impact. But this can only be done if practitioners understand how to develop messages that speak to both the imagination and the intellect at the same time."

Being able to speak to both the imagination and the intellect of listeners simultaneously requires hard work, and at National Public Radio, where journalistic storytelling is done via sound more than with any other media organization in the United States, its reporters have figured out a pattern that works well and is worthy of being used to pattern almost any storytelling narration that you might create, be it news or entertainment.

NPR radio stories almost always start with an introduction by the host, Andrea Hsu of NPR's *All Things Considered* said. From there, though, elements are blended together in the same way they would be for video and filmmaking. You might, however, think of any dialog as the images in your video with the sounds and music highlighting what has been said. Sometimes the sound will lead the dialog. At other times, it will work in reverse. Either way, the two together create the visual images in your mind and complete the story.

Recording Sounds

If you do plan on recording your own sounds—music, background sounds, or voices for an interview—you will have to use a microphone. Some basic information about types of microphones and their recording patterns will help you achieve the best possible recording.

First, microphones vary in quality, but all of them record in patterns. This is important to know if you plan either to record sounds only or if you plan to interview someone and record their speaking to you. Some microphones have an omnidirectional sound pattern. This means that they record in all directions from the end of the mic. They would work well for ambient and natural sound but not very well if you're looking to focus in on one particular sound or voice in a large room or open space. If you wanted to collectively record musical instruments in a live setting, then an omni-

directional mic would be a good choice. Most lavalier or lapel microphones (those that are clipped onto a person being interviewed) are omnidirctional. Since they are affixed to clothing, they will pick up all sounds in front of them. Generally, an omnidirectional lapel mic focuses in on the voice of the person being recorded because of the close location to the person's mouth, which allows the recording volume to be set at a lower level. This helps isolate the voice and keep some of the ambient sounds out of the recording.

Other microphones employ a cardioid pattern, which means they record sounds that are directly in front of the mic and limited sounds from the sides of it. This type of microphone tends not to pick up sounds that are behind it. The sound recording pattern of a cardioid microphone resembles a heart, hence the name of its pattern. Cardioid microphones are good for use in recording vocals and where your recording environment has fairly good acoustics.

> Some microphones employ a cardioid pattern, which means they record sounds that are directly in front of the mic and limited sounds from the sides of it. This type of microphone tends not to pick up sounds that are behind it.

A hypercardioid microphone is a variation of the cardioid. It records extremely well sounds that are directly in front of it. It ignores all sounds behind the mic, and it only records a small amount of sounds that come from its sides. If you are worried about the possibility of feedback (sound that has been amplified and is picked up by a mic and re-amplified causing a squealing sound to be produced), then a hypercardioid microphone is a good choice. With this type of microphone, the sound being recorded is confined to a much smaller recording space than other types of microphones.

A fourth type of microphone is a bidirectional microphone, also referred to as a figure-eight mic. These record sound directly in front and behind the microphone but not from the sides. This type of microphone would be a good choice if you want to record two speakers and not pull in unwanted ambient sounds.

In some situations, media professionals use a shotgun or a boom microphone. Unlike most omnidirectional and cardioid mics, which are hand held or fixed on a stand, the shotgun microphone is used on a boom when recording. It's the kind of mic that would be used to record conversation in TV programming, for example. It picks up all sounds within about three feet of the microphone. You may have noticed this type of microphone in a shot of a TV program that is recorded live, like a talk show. The microphone is not supposed to be in the shot but just above the camera's

eye. Sometimes, however, you can see these mics when shows go to a commercial and provide a wide-angle shot of the set.

Knowing the environment in which you need to record sound is important for determining what type of pattern mic you need. You will probably not see the directional pattern written on the microphone, so it would be good to ask the pattern if you are renting or borrowing equipment.

CHAPTER QUESTIONS

1. Why are MP3s critical to the use of sound in the digital, online world?

2. Find two Web pages that provide sound, one that plays the sound automatically and one that only plays sounds at the user's request. What are your reactions to the sound on both of these sites? Is it really a negative for the site to play sounds automatically and why?

3. When dealing with sound on the Web, what are the legal issues that will affect what you use? Using the chapter on law from this book and the idea of "heart of the matter," determine what part, if any, of your favorite song you might be able to use as part of a Web site.

4. You have a video that moves from a scene on a busy street to a quiet restaurant. There's no talking with your scenes, only music. What would be the best sound transition for the music in this situation and why?

5. Why is it important for you to know what type of sound recording pattern a microphone has before you begin a recording session?

10 Bringing It All Together

This book has helped you think more critically about how you create media content in today's world of technologically sophisticated, visually rich, and ubiquitously accessible communications. You've learned about history, law, ethics, and the power of images. You've also looked at framing of still and video images and the use of sound. Professionals working in these fields are more often than not required to create a variety of content for a wide range of distribution platforms. This chapter will offer several examples of media content created for the Web, radio, television, or theatrical release. We'll pay special attention to the ways in which a given message is altered depending on the chosen delivery format. We'll also address the many ways that the issues brought up in earlier chapters are put into play to address the many goals of the example projects.

As you can see, this book has demonstrated how key components of creating a range of communication messages work. In doing so, each component has been discussed and examined independently. Though it is important for you to understand each of the topics in the preceding chapters, it is also vital that you realize how to use them together as you synthesize your raw ideas into finished projects. The following examples will illustrate how key concepts function in film trailers, Web and radio journalism, the music industry and corporate marketing.

First, we start with an example from the *Lexington Herald-Leader* where a pioneering photojournalist tackled a serious topic for a Web-based multimedia story. Let's take a look at what decisions were made in terms of platform and delivery as well as how those choices showcased the best of each medium as it was delivered via an online version of the story.

KEY TERMS

CG model

foursquare

Gowalla

multimedia journalism

RED camera

story-arc

style frames

Twitpic

TwitVid

UStream.tv

Figure 10-1: The homepage for the "A New Dawn?" project.

"A New Dawn?"—Lexington Herald-Leader

What began as a routine assignment to cover a graduation ceremony for recovering drug addicts inspired photographer David Stephenson to tell the story of one mother struggling with her demons. More than four years later, Stephenson's dogged determination resulted in a groundbreaking piece of multimedia journalism, "A New Dawn?," which garnered numerous professional awards, including the 2008 Best Multimedia Project in the Pictures of the Year International competition.

Stephenson, then working for the *Lexington* (Ky.) *Herald-Leader,* teamed with reporter Mary Meehan to follow Dawn Nicole Smith, a 22-year-old mother of three, as she struggled to complete the terms of a Kentucky drug program that substitutes treatment and frequent court appearances for prison time. The project shows in harrowing detail the difficulties faced by Smith, who had forged prescriptions, in trying to put her life together.

Pursuing the project between daily assignments for the newspaper and often spending nights and weekends away from his family while working on the story, Stephenson shot more than eight thousand photographs and gathered more than ten hours of audio interviews in three-plus years. In the print version of the *Herald-Leader,*

Stephenson and Meehan's work was transformed into a six-day, 18-page series. Online, "A New Dawn?" became a vehicle for Stephenson's vision for the story, incorporating 130 photographs into five "chapters," accompanied by interview clips and original music created by a local hip-hop group that gave Stephenson unlimited rights to use its work.

"The New Dawn (online) project was shot, recorded, edited, produced, designed and posted by only one person—me," said Stephenson, who now teaches at the University of Kentucky and is a freelance multimedia journalist. "There was no collaboration. It was a singular vision, which in fact may have helped. I had a few friends serve as 'testers' for me along the way, but it was 95% complete before I showed it to the reporter or editors. They all contributed in the end. While I don't recommend that always, I do believe that having an almost obsessive personal vision for a project is a powerful tool."

To achieve his vision, Stephenson faced a daunting array of material, which he managed by thoroughly cataloging each day's work and tagging the most promising photographs and sound clips as he went along. Over time, the thousands of photographs were culled to hundreds, then dozens. In order to create the interface he envisioned, Stephenson dove into the multimedia software Flash by taking an online tutorial. The software was merely a tool though to assist Stephenson in constructing an appropriate narrative.

Figure 10-2: Stephenson obtained extraordinary access for the story. In this photograph, Dawn receives a visit from her children while she is in jail. (Photo courtesy David Stephenson)

"What I tried very hard to do when producing the project was to have a good, solid story-arc. Dawn's story, one of struggle and ultimate failure, was very compelling. If I had simply made a chronological slide show put to music, it wouldn't have been nearly as effective," Stephenson said.

"The chapters themselves varied in subject, length, and style so that they wouldn't seem repetitive," Stephenson continued. "I tried to make them as compelling as I could in the first few seconds and have a natural ending that would lead into the next chapter. I chose to use text slides to help readers along when something needed clarifi-

cation—I did not want to introduce the voice of a narrator. Hearing Dawn's voice and the voices of the judges and case workers was essential for the viewer to connect—it's a very valuable asset to have."

Smith agreed to let Stephenson and Meehan have virtually unfettered access throughout her three-plus years in the drug program, which made for compelling storytelling. At the same time, Smith's struggles also forced Stephenson to anticipate potential ethical dilemmas.

"Should I keep her toddler from sticking something in a power outlet while she was preoccupied with another child? At what point would we be obliged to notify authorities if her children were possibly unsafe or being mistreated?" Stephenson asked in *News Photographer* magazine. "We had frequent discussions between ourselves and with editors about what to do if we witnessed something that needed to be reported to authorities. If Dawn's children had appeared to be at risk, we would have been bound, like all citizens, to report it. And we wouldn't have hesitated."

> **"** *The New Dawn (online) project was shot, recorded, edited, produced, designed and posted by only one person—me. There was no collaboration. It was a singular vision, which in fact may have helped. I had a few friends serve as 'testers' for me along the way, but it was 95% complete before I showed it to the reporter or editors. They all contributed in the end. While I don't recommend that always, I do believe that having an almost obsessive personal vision for a project is a powerful tool."* **"**
>
> **DAVID STEPHENSON**
> MULTIMEDIA JOURNALIST

Aside from the awards and acclaim, Stephenson's work hit its intended goal of bringing more local attention to the drug court program and the struggles of those in it. Reader reaction was overwhelmingly positive, many commenting that they had a loved one who was currently fighting or had battled substance abuse. Clearly, being able to deliver a truly in-depth story via the online version enabled Stephenson to affect his readers at a deeper level.

"Perhaps telling Dawn's story will shed light in areas where most people don't want to look," Stephenson wrote shortly after the series was published. "Maybe readers will have a little more compassion and understanding."

Stephenson's work goes well beyond the traditional work of a photojournalist at a newspaper in scope of coverage and time devoted. For some, the Web work is secondary to the main format. However, in this case the Web component became the richer, more compelling vehicle in which the full story emerged. You can view the project at http://www.heraldleaderphoto.com/dawn/.

National Public Radio—*All Things Considered*

National Public Radio (NPR) creates stories primarily for radio airplay. Initially its Web site housed archived editions of segments that had already played on air. Producers decided early on that they were not going to become a go-to news site in the way CNN or the *New York Times* has become. Instead, they use the Web content to enhance the radio content by bringing in visual elements that you just can't use in a radio broadcast. The staff at *All Things Considered*, one of a handful of NPR news programs delivered in the afternoon, produces a wide range of content for radio. But more and more, reporters are thinking about their work in terms of how it will also work for the Web. Sometimes

> The staff at *All Things Considered* produces a wide range of content for radio. But more and more, reporters are thinking about their work in terms of how it will also work for the Web.

they hold back on some story material for Web delivery so that they have original material for that medium. The standard formula involves a paragraph summarizing what the story on air was about and then, since they don't have the staff to write full Web-delivered text for every interview featured on air, a recorded transcript of the interview. For example, if the afternoon show features a segment about the new Dan Brown book, the Web producer might post some wire photos of Brown, add a link to an earlier interview with Dan Brown, write a whole different first paragraph as a lead-in for the story, and adapt the interviews included in the broadcast piece: http://www.npr.org/templates/story/story.php?storyId=112884584.

On Labor Day weekend, Noah Adams was working on a radio piece about KitchenAid mixers. He went to the factory and we get to hear what it's like to be there. We also get to hear from employees who work there. You really feel like you're with Noah as he learns about the mixer. We then go with him to a KitchenAid sponsored 4-H Club Teen Bake-a-Rama and hear the cooking, sounds of the county fair and applause during the announcement of winners. You can hear the story and see the transcript here: http://www.npr.org/templates/transcript/transcript.php?storyId=112620794.

The online producer adapted the script, staying pretty close to Noah Adams' original language, but transformed the story into a much shorter piece for the Web (http://www.npr.org/templates/story/story.php?storyId=112620794).

A nice repurpose, but *All Things Considered* Producer Andrea Hsu said they could have done better, "I think the Web version

Figure 10-3: NPR accompanied a Labor Day radio story with an online-only slideshow about jobs and the people who do them.

could have benefited quite a bit from other elements, such as an interactive timeline, which could show the history of the KitchenAid mixer, and definitely at least one photo of a mixer itself, if not a slideshow of different mixers over the years showing the various colors and styles. I was surprised to see that there was not a single photo of the mixer on the page! These are the kinds of things we are thinking about more and more as we go forward. In this case, I think we didn't make the most of this story on the Web."

Producers did it better with a story about snoring where they added a Web chat and an interactive game where the Web visitor can guess the snore sound for a number of NPR reporters (http://www.npr.org/templates/story/story.php?storyId=101434831). At times they create Web-only content that is not connected to related radio broadcast content but rather a particular standard news cycle. So while they did the Labor Day KitchenAid story for ra-

dio and Web, they also produced a Web-only series of audio and still slide shows about various jobs and the people who do them. They linked this to an on-air interview about labor statistics (http://www.npr.org/templates/story/story.php?storyId=112440700). Hsu said, "My original thought was to do a whole series of these slideshows, but we're still trying to find out if creating Web-only content makes sense, or whether it makes better sense to tie Web features into on-air stories. The audio slideshows are pretty time-intensive, so the question is whether it's worth the time to do something that appears only on the Web and hence has a much smaller audience. As you can see, our thinking about the Web is constantly evolving and will probably be somewhat different by the time [this] book is published."

Augmenting Television Election Coverage

In an effort to prepare viewers to make informed decisions on Election Day, television reporter Matt Belanger at Hearst-owned WGAL-TV in Lancaster, Pennsylvania spends much of his workday in the month leading up to each election fact-checking as many political television ads and candidate speeches as possible. Belanger's "Ad Watch" series, which is similar to fact-check reports presented by other stations, has become very popular with viewers as each report rates the truthfulness of claims being made by candidates and presents research to support that ranking, as well as help viewers better understand the facts. But Belanger takes the effort one step further by concurrently building an interactive, online database of the claims as he checks them for his on-air presentations. Viewers can watch a traditional broadcast version of each of his reports during a regularly scheduled newscast. Or, they can go online to the station's Web site at their own schedule to find a list of the claims being made and then a summary of Belanger's research. The online presentation is complete with links to the same documents and sources Belanger used to analyze and rate the truthfulness of each claim.

"In an era when television often becomes 'background noise' to our daily lives, we found our fact-checking reports have become 'must-see' television among our viewership," Belanger said. "They were eager to hear how truthful we found the claims they've been hearing to be and be presented with the 'whole story' that candidates often strategically avoid."

Viewers seem to appreciate the ability to examine things for themselves, as the fact-check section of the Web site performs well as Election Day nears. Many times, the online component to Belanger's reporting will often prompt a viewer response. Some individuals who read the information will email with criticism or praise or even suggest a claim they've heard somewhere for Belanger to check. The broadcast and Web-based components stand independently but also support each other in their effort to foster an informed electorate. "Our viewers really are an extra set of eyes and ears for us as we cover campaigns," Belanger said. "Many times some of my best stories come from viewer e-mails."

DevaStudios—*The Expendables*

For those working in film advertising, trailers are advertisements for upcoming films that are usually viewed on television and or in a theater. They are increasingly available online as well. When they are, the content is often adjusted for an online delivery platform. Here is the story of how one teaser trailer was created for a major studio film.

Lionsgate is known for a bold artistic vision in the marketing materials they create. They often do things that other studios are

Figure 10-4: The DevaStudios team showed the client "style frames"—rough concept art for films that are meant to evoke a feeling, a tone or a look and to give a visual clue of the intentions for the trailer.

afraid to do for fear of losing the audience. When it came time to market the Sylvester Stallone film, *The Expendables*, Lionsgate contacted DevaStudios and Fishbowl Films. Because of Stallone's prior films, people expected this film to be a typical action shoot 'em up film. And in many ways it is. "But they wanted to do something that went slightly counter to everyone's impression of what the film is: To come up with a couture/post-modern type look," said Kelly Carlton of DevaStudios.

Images of a skull and a bird figure prominently in the film. The client had an idea to do a stylized piece as a teaser that would demonstrate the attitude of what this film was going to deliver. Something edgy but that also possessed an artistic angle that would suggest this is not just an action-only film. Carlton said, "So we basically had the assignment of creating something provocative and couture with a bird and a skull." No easy task!

The team brainstormed ways to make the bird and skull exciting. At the end of the day, the idea was to showcase a skull with footage from the feature reflected on its surface and a bird standing on top and possibly have it flying off the skull. The designers were challenged in trying to make that basic premise interesting. So they started to think about the texture of the skull, the lighting, the environment, and a selection of images from the film they could use. The team showed the client "style frames"—rough concept art for

Figure 10-5: Carlton and two other art directors set up the lights and worked with the bird trainer to capture the shots that they needed.

films that are meant to evoke a feeling, a tone or a look and to give a visual clue of the intentions for the trailer. The studio was presented the first set of images, and then Deva worked back and forth to establish an agreed-upon look so the CG process of could begin.

After getting the go-ahead from their client, Fishbowl and Deva bounced the concept back and forth between their two shops. Fishbowl started playing with music and dialogue and began cutting images together with crude stand-in imagery of a skull and bird. Meanwhile, Deva worked on developing the bird and skull content.

The DevaStudios team liked the idea of a computer-generated (CG) model of the bird that they could control and modify if necessary. Ultimately they decided against this direction as the development of the CG model would take them over budget because of the many hours needed to create this asset. In many instances, the strongest artistic vision isn't necessarily the most economically feasible. "Basically, we decided not to animate the bird because of cost. So I talked to my brother-in-law who does shoots with live animals and was able to get an African raven, similar to the one represented in the film. Interestingly, the bird had a white ring around its neck that had to be dyed black. They are required to use an international species because of a law about using domestic birds," Carlton said. The team decided the way they needed the bird to fly. The animal company then spent a week training the bird to do specifically what DevaStudios required. They shot the bird scenes with a Director of Photography who owns his own RED camera. Carlton said it is much more affordable to contact people who are experts with their own equipment because it makes for a more efficient shooting day. Carlton and 2 other art directors set up the lights and worked with the bird trainer to capture the shots that they needed.

> In many instances, the strongest artistic vision isn't necessarily the most economically feasible.

Once they shot the footage they sorted through it to find the best takes and angles needed to construct the different sections of the teaser. As DevaStudios works on the bird and skull imagery and on the main title portion they collaborate with Fishbowl during the process. As each team makes progress, they share their content with each other. Working this way, the teaser gets updated accordingly. This type of workflow goes back and forth over the course of many iterations. 3D playblasts and 2D renders with place-holder footage are often used to quickly demonstrate the creative intentions.

Once the cut is far enough along, progress presentations are made to the client. At each presentation the client gave the Fishbowl team notes, which were then shared with the DevaStudios staff. The teaser was constantly adjusted based on the feedback received from the client. The final teaser was screened for the client.

After getting the client's approval, the final teaser was taken to a digital intermediate (DI) session where the team gets to see how the content looks before it goes to film. Part of this process is getting to view the finished version of the teaser at full film resolution. Film resolution is usually much larger than the resolution that the team uses as they work on a film project. In simple terms, a DI is basically a process used by post facilities to convert the film resolution outputs into a version that is very close to what it will look like in the theater. "When you are working, most of the time you are looking at a lower resolution QuickTime movie file, not something in HD quality, so a DI session in the final stages of a project allows us see what it will look like, not only on film, but also at speed. You can adjust color and address any little issues you want to fix. Sometimes the problems are more evident when the picture is blown up large. So we make changes and re-output the content and then head back to the DI and look at it again," Carlton said.

A similar process happens with sound where sound mixers tweak numerous aspects of the audio tracks. The attention to detail that is paid to every nuance of the teaser during a sound mix is impressive. It's unlikely that you would ever notice the modifications and enhancements when you're consuming the online version of a trailer, but you certainly will when you do so in a theater. After the team is happy with both picture and sound, then the head of finishing and the creative executive for the studio approve the final version.

> After the final trailer goes through sound and picture correction, a compressed version is created for online viewing.

Watching a trailer online used to be an anomaly. Today people routinely view and share film trailers through social media and blogs. Film advertisers are aware that many more people are watching trailers online than in theaters or on television. Because of this, after the final trailer goes through sound and picture correction, a compressed version is created for online viewing. It takes a high amount of compression to successfully put film trailers online. That degree of compression can tweak colors and contrast levels, create noise artifacts, and can introduce unintended effects such as staircase images around curved edges or mosaic patterns in images. Giv-

en the potential for beautiful, sophisticated imagery to turn sour, motion picture advertising companies seek an extra level of color correction for any film content delivered online. In the hands of a seasoned professional it is possible to successfully compress this type of content such that it will play back smoothly when viewed on a Web site and look almost as good as the version released theatrically.

Here is the online version of the trailer: www.devastudios.com/theExpendables/

Interscope, Geffen and A&M

The changing nature of the profession is a common theme in many of the conversations we had with professionals. Adjusting to the demands of new media of many types and to the expectations of a more sophisticated audience is one key to success in today's media landscape. This is perhaps most true in the music industry, where new technology has forced the industry to rethink the whole way it does business.

Understanding social media will be a given as you move into the world of professional media, but how does it all play out in the real world in contrast to personal usage?

Knowing how to shoot video, work with images in programs like Photoshop and Illustrator is great. Knowing how to create a Web site and how to add content such as still and moving images, sound, and hyperlinks to other pages and to other sites provides you with tools that are essential in the twenty-first century. Understanding and using social media will be a given for you as you move into the world of professional media, but how does it all play out in the real world in contrast to personal usage? For Margot Stephenson, general and online marketing expert at Interscope, Geffen, and A&M records, all of these skills are a part of the everyday toolbox she uses to promote music. She understands that these skills are interchangeable for any product that media may push, from products to news. She also knows that using social media is a quick way to connect with thousands, perhaps millions, of people. Here's what she has to say about emerging platforms in social media.

"Many major corporations know that social media are important. CEOs and executives read news about the importance of doing business online. They take a look around and realize they should have built a new media department years ago. They hire specialists to ensure they're getting the best out of their search engine market-

ing and social media strategists to effectively position their company on Facebook, MySpace, and Twitter. They hire a mobile developer to create iPhone applications for their brand. But while they've covered these bases, simply adjusting where they do their marketing does little to impact the way they do business on the whole.

"The Internet has drastically changed the way consumers think, feel, and consume. It allows the average person to make informed decisions about how and when they spend money. Marketing and advertising are no longer about having a great television spot that captures people's attention. In order to be successful, brands must offer a unique and quality product or consumers will lose interest.

"Social media offer a unique method for interacting directly with consumers on a daily basis. Many celebrities have realized that rather than having tabloids broadcast false information about them on a regular basis, they can use Twitter to speak to fans directly and honestly. Brands have found that rather than using a press release they can share their news directly with their consumers that have "become fans" on Facebook. Musicians no longer need the help of a manager or record label to share their music because there are a multitude of places they can post their music and get direct feedback online. The biggest question many people have about these new tools is how to make their talents and/or products stand out."

To that end, Margot suggests the following best practices.

Try Them Yourself. Never decide to start using a form of social media for your company until you've created a personal account and fully understand why it's popular and useful. Add friends, put up a personal picture and play with every feature. This is really the only way to get the most out of an online medium.

As a music fan and digital marketer, Margot follows a multitude of music blogs, including those of her favorite musicians, tech blogs, and owners of digital media companies to ensure she's hearing exactly what's going on straight from the people who know best. If a company has a question about how to market something online, she's the first to respond to let them know her experience. When a musician posts a new tour date in her area, she reposts (retweets or RT) it to tell friends they should go.

Create a unique and distinct voice. Many brands try to assign one person to post content online in the same way they'd title a press release. The online environment provides for a much more casual and interactive place than print media does. Brands that are successful encourage customer service representatives to use their names in their Twitter handles and to speak in the first person directly to their customers. Instead of just posting news about the company, they post news that's relative and may be interesting to their audience.

Zappos is the brand that stands out as having succeeded in utilizing Twitter to the fullest. Company CEO Tony Hsieh tweets regularly at Twitter.com/Zappos and now has more than 1.6 million followers. He writes in first person, weaving news about the brand and articles he finds interesting. He shares pictures and even song quotes. He explains his success with Twitter in his article "How Twitter Can Make You a Better and Happier Person": "Think of each tweet as a dot on a piece of paper. Any single tweet, just like any single dot, by itself can be insignificant and meaningless. But, if over time, you end up with a lot of tweets; it's like having a lot of dots drawn on a piece of paper. Eventually there are enough dots for your followers to connect. And if you connect the dots, in the aggregate it paints a picture of you and/or your company, and it's that total picture that is your brand."[1]

> Zappos' CEO writes in first person, weaving news about the brand and articles he finds interesting. He shares pictures and even song quotes.

Read what people are saying about your brand. Regardless of the medium which brands choose for communication, there is always the capacity for the audience to respond. If a corporation has posted two news stories, responses from the public should be read to gauge how the information is being received. Many times, depending on whether or not users find the content interesting or annoying, they'll let you know if they want more information on different content or simply if they think you're doing a great job. It's easy to find out quickly.

Respond to responses. When there's a pointed, well-educated, negative reaction, respond. Many brands work hard to persuade consumers to care about their products, but social media provide a unique opportunity to show that the brand appreciates them in

1. Tony Hsieh, "How Twitter Can Make You a Better (and Happier) Person," http://blogs.zappos.com/blogs/ceo-and-coo-blog/2009/01/25/how-twitter-can-make -you-a-better-and-happier-person.

return. A friend posted on Twitter: "I used to love @AmericanEx-
press for their amazing customer service and how I was treated, but
I may cancel my account after 11 years."

Someone at American Express was paying attention. The cus-
tomer was promptly responded to by American Express on Twit-
ter about the problem and how it could be solved. My friend was
pleased with how quickly American Express solved his problem and
decided to remain an American Express customer.

Stay on top of new developments: Twitter now has a multitude
of add-ons that enrich the experience. Web sites and applications
such as Twitpic, TweetPhoto, and YFrog allow a user to add a pic-
ture to their Twitter feed. Here's how they can be used in the cor-
porate world of music.

A musical group, let's say Aerosmith, could walk on stage at an
arena and ask everyone in the audience to take a picture of them
with their phone, reply to their Twit-
ter name and post it on Twitter. Fans
would immediately take a picture, post
it on TwitPic with an @reply (@ de-
notes a response to another user and
precedes the user's Twitter name) to
the band's Twitter account and a mes-

> Applications such as Twitpic,
> TweetPhoto, and YFrog allow a user
> to add a picture to their Twitter
> feed. Here's how they can be used
> in the corporate world of music.

sage "seeing Aerosmith in concert." This tweet not only broadcasts
to the followers of every person who posts it but the @reply provides
an easy link for those followers to click and begin following the mu-
sicians. This simple step before a show could increase the musicians'
capability to broadcast directly to new fans by thousands.

Tools like TwitVid, Twiddeo, and Twitc add another capa-
bility of video to Twitter. Additionally, sites like UStream.tv and
Justin.tv allow users to broadcast live video content and have the
functionality to automatically send an alert to Twitter followers,
letting them know when they're live. Promotions using these tools
have worked successfully for conducting live auctions, fundraising
events, streaming fashion shows, and live concerts.

Location-based applications are the newest trend in social me-
dia. While Twitter, Facebook, and MySpace focus on what you're
doing, location-based apps take it one step further and ask: Where
are you, and what are you doing?

Foursquare is a mobile application that users download to
their phones and use to "check-in" every time they're in a new lo-
cation (typically used for restaurants and entertainment venues).

Each check-in earns users points toward different badges simply by exploring their city. Users have the option of broadcasting each "check-in" to Twitter to let their friends know they are there. Gowalla is similar to Foursquare but has a more captivating design interface and fewer social capabilities. It focuses on encouraging users to check in at different locations in order to collect different digital goods. Rather than badges, they're called "pins," "items," and "stamps." Gowalla shows more promise for marketing purposes because it doesn't allow users to check in unless their GPS coordinates guarantee that they are actually where they say they are.

Location-based applications encourage social media enthusiasts to get away from the computer and experience the world. Brands have quickly noticed this growing trend and have begun partnering with Foursquare and Gowalla to communicate with this active audience.

As you can see from these examples, most media projects involve a variety of media types. Most projects involve some combination of graphics, photographs, text, video, and other more specialized types of media. Very few projects employ only one of these media types. As a producer of rich media content, you will need to demonstrate a broad range of knowledge and possess a wide array of skills. Though you may excel or specialize in a particular aspect of media production—say photography or graphic design or video editing—you still need to be effective with a range of technologies.

> The clients and organizations that you work for will demand that the content you create be technically sophisticated and visually compelling.

These days, one of the most important general skills that all media producers should have some experience with is Web design and development. Content of all types is being delivered via the Web; it's very likely that the projects you work on will have at least some relationship to a Web-based or otherwise networked distribution channel. As we move into a future that is increasingly dominated by ubiquitous, always available rich media and by mobile, handheld smart devices, the clients and organizations that you work for will demand that the content you create be technically sophisticated and visually compelling. In this new media environment, images and stories will become the dominant form of communication surpassing the written word in value. Communicators will realize the inherent value in being able to deliver their messages through images that transcend any language limitations. Being skilled at crafting

sophisticated messages using images, sound, and narrative structures will have you well positioned for success in the communications industry of today and of tomorrow.

CHAPTER QUESTIONS

1. What are the advantages to a multimedia online story over a traditional print story on the same subject?

2. How might a Web version of a radio news story differ from the same one that might be found online?

3. How are traditional media using email as a means of enhancing reporting and stories?

4. Many potential employers will expect you to be able to create strong visual Web sites, and they will also expect you to be a savvy user of social media. Find a Web site that you believe is well designed and informative. How does it use social media? How does it enhance the site and its information?

5. Go to *The Expendables* trailer Web site (www.devastudios.com/theExpendables) or another site that has a movie trailer. Think about all that this book has taught you about design principles and then evaluate the trailer you chose for its positive elements of design. Also, look to see what elements of the trailer's presentation that you think could be improved.

Sources

A 21St Century Ethical Toolbox (2001). New York: Oxford University Press.

Alten, S. R. (2008). *Audio in Media*. 8th ed. Belmont, CA: Wadsworth.

Altschull, J. H. (1990). *From Milton to McLuhan: The Ideas Behind American Journalism*. New York: Longman.

Baker, C. E. (1978). "Scope of the First Amendment Freedom of Speech." *UCLA Law Review* 25, 964-1040.

Baker, S. (1999). "Five Baselines for Justification in Persuasion." *Journal of Mass Media Ethics*, 14(2), 69-81.

Ball, J., Carman, R., Gottshalk, M., & Harrington, R. (2010). *From Still to Motion: A Photographer's Guide to Creating Video with Your DSLR*. New Riders Press.

Barnett, B. (2003). "Threatening and Guilty: Visual Bias in Television News." *Journalism and Mass Communication Monographs*. Volume 5 Number 3.

Barnett, B. & Grabe, M. E. (2000). "The Impact of Slow Motion Video on Viewer Evaluations of Television News Stories." *Visual Communication Quarterly*, 7(3), 4-7.

Beaird, J. (2010). *The Principles of Beautiful Web Design*. 2nd ed. Melbourne, Australia: SitePoint.

Black, J. And Bryant, J. (1995). *Introduction to Media Communication: Understand the Past, Experience the Present, Marvel at the Future*. Madison, Wisc.: Brown & Benchmark.

Bok, S. (1978). *Lying: Moral Choice in Private and Public Life*. New York: Pantheon.

Bruce, T. (2003). *The New Thought Police: Inside the Left's Assault on Free Speech and Free Minds*. Roseville, CA: Prima Publishing.

Christians, C. G., Fackler, M., Rotzoll, K. B., & McKee, K. B. (2001). "Introduction Ethical Foundations and Perspectives." In *Media Ethics: Cases and Moral Reasoning*. (6th Ed. New York: Addison Wesley Longman.

Fiss, O. (1996). *The Irony of Free Speech*. Boston: Harvard University Press.

Fitzpatrick, K. & Gauthier, C. (2001). "Toward a Professional Responsibility Theory of Public Relations Ethics." *Journal of Mass Media Ethics*, 16(2 & 3), 193-212.

Grabe, M.E. (1996). "The South African Broadcasting Corporation's Coverage of the 1987 and 1989 Elections: The Matter of Visual Bias." *Journal of Broadcasting and Electronic Media*, 40, 153-179.

Grunig, J.E. (2000). "Collectivism, Collaboration and Societal Corporatism as Core Professional Values of Public Relations." *Journal of Public Relations Research*, 12(1), 23-48.

Haines, R. (2001). *Digital Audio*. Scottsdale, AZ: Coriolis.

Hook, P. (2006). *Digital Photography*. New York: Collins.

Horton, B. (2001). *Associated Press Guide to Photojournalism*. New York: McGraw-Hill.

Huang, SH (2001). "Readers' Perceptions of Digital Alteration in Photojournalism." *Journalism & Mass Communication Monographs* 3: 149-182.

Kepplinger, H.M. (1982). "Visual Bias in Television Campaign Coverage." *Communication Research*, 9(3), 432-446.

Kobre, K. & Brill, B. (2000). *Photojournalism: The Professionals' Approach*. Boston: Focal Press.

Lester, P.M. (2005). *Visual Communication: Images with Messages*. 4th ed. Boston: Wadsworth.

Lewis, A. (1991). *Make No Law: The Sullivan Case and the First Amendment*. New York: Random House.

Mandell, L.M. & Shaw, D.L. (1973). "Judging People in the News Unconsciously: Effect of Camera Angle and Bodily Activity." *Journal of Broadcasting*, 17(3), 353-362.

McNeil, P. *The Web Designer's Idea Book, Volume 2*. Cincinnati, Ohio: How Books, 2010.

Meiklejohn, A. (1961) "The First Amendment Is an Absolute." *Supreme Court Review*, 245-66.

Nielson, J. & Pernice, K. (2009). *Eyetracking Web Usability*. Berkeley, CA: New Riders Press.

Patterson, P. and Wilkins, L. (2010). *Media Ethics: Issues and Cases*. New York: McGraw-Hill.

Peterson, B. (2010). *Understanding Exposure: How to Shoot Great Photographs with Any Camera*. 3rd ed. New York: Amphoto Books.

Pohlmann, K. (2010). *Principles of Digital Audio*. 6th ed. New York: McGraw-Hill.

Potter, R. (1972). "The Logic of Moral Argument," in Paul Deats (Ed.), *Toward a Discipline of Social Ethics*. Boston: Boston University Press.

Potter, R. (1965). "The Structure of Certain American Christian Responses to the Nuclear Dilemma, 1958-63," Ph.D. Diss., Harvard University.

Rabban, D. M. (1981). "The First Amendment in Its Forgotten Years." *Yale Law Journal* 90, 514-95.

Reaves, S. (1993). "What's Wrong with This Picture?: Daily Newspaper Photo Editors' Attitudes and Their Tolerance Toward Digital Manipulation. *Newspaper Research Journal* 13 & 14: 131-155.

Reynolds, A. & Barnett, B. (2006). *Communication and Law: Multidisciplinary Approaches to Research.* Mahwah, NJ: Lawrence Erlbaum & Associates.

Reynolds, A. & Barnett, B. (2003). "Free Speech Implications in the Wake of September 11" in N. Chitty, R.R. Rush and M. Semati (Eds.), *Studies in Terrorism: Media Scholarship and the Enigma of Terror.* Malaysia: Southbound Press in association with the *Journal of International Communication.*

Ross, S.D. (2004) *Deciding Communication Law: Key Cases in Context.* Mahwah, NJ: Lawrence Erlbaum.

Sadler, R.L. (2005). *Electronic Media Law.* Thousand Oaks, CA: Sage.

Sloan, W.D. & Parcell, L. M., Eds. (2002). *American Journalism: History, Principles, Practices.* Jefferson, NC: McFarland.

Smith, K., Moriarty, S., Kenney, K. & Barbatsis, G. (eds.). (2005). *Handbook of Visual Communication: Theory, Methods, and Media.* Mahwah, NJ: Lawrence Erlbaum.

Taylor, A. (2010). *Design Essentials for the Motion Media Artist: A Practical Guide to Principles & Techniques.* Boston: Focal Press.

Tiemens, R. (1970). "Same Relationships of Camera Angle to Communicator Credibility." *Journal of Broadcasting,* 14(4), 483-498.

Wiggins, G. (1995). "Reporters and Legal Issues," in Bruce J. Evensen, *The Responsible Reporter.* Northport, AL: Vision Press, pp. 81-103.

Wonnell, C. T. (1986). "Truth and the Marketplace of Ideas." *University of California at Davis Law Review* 19, 669-727.

Zettl, H. (2007). "Sight, Sound, Motion: Applied Media Aesthetics." 5th ed. Thousand Oaks, CA: Wadsworth.

Index